Nothing and Everything

Nothing and Everything
Seven Artists, 1947–1962

Louise Bourgeois, John Cage, Morton Feldman,
Philip Guston, Franz Kline, Joan Mitchell, David Smith

Douglas Dreishpoon

Hauser & Wirth Publishers

Silence is a subject that interests me tremendously. The length of the silence, the depth of the silence, the irony of the silence, the timing of the silence. The hostility of the silence. The shininess and love of the silence.

—Louise Bourgeois, 1983

Nothing is not a strange alternative in art. We are continually faced with it while working. In actual life, this experience hardly exists.

—Morton Feldman, 1966

There is an essential difference between making a piece of music and hearing one. A composer knows his work as a woodsman knows a path he has traced and retraced, while a listener is confronted by the same work as one is in the woods by a plant he has never seen before.

—John Cage, 1957

But John, it's about everything
Douglas Dreishpoon

The painter Philip Guston must have been elated: it's not every day that two composers sympathetic to your work come to your studio to see what you're doing. John Cage and Morton Feldman appeared at Guston's Tenth Street studio, the space he occupied during the winter months until spring came and he retreated, with his wife and daughter, upstate to Woodstock. By the time of their visit, Cage had been writing experimental music for more than thirteen years. His reputation in mainstream circles was still as an outlier, but not among an expanding cohort of visual artists more in tune with his open-minded attitude toward art's intersection with life. Fourteen years Feldman's senior, Cage was no stranger to the visual arts and to the intimate setting of an artist's studio. Feldman first met Guston at Cage's minimally furnished downtown loft overlooking the East River, and he subsequently saw his first Guston, again with Cage, at The Museum of Modern Art in 1950, shortly after the musicians had serendipitously encountered each other in the lobby of Carnegie Hall at a New York Philharmonic concert that featured a work by Anton Webern.

A unique triangular relationship developed between Feldman, Cage, and Guston that, at least in Feldman's mind, nurtured an aesthetic philosophy. "It is significant that in all these years Philip Guston and John Cage are equally important to me," he recalled in 1966. "During those [early] years we all talked constantly about an imaginary art in which there existed almost nothing. In a sense it was a three-way conversation, though I never brought the ideas of one to the attention of the other, and as far as I know, Guston and Cage never talked about it together. . . . It was my role as double agent in keeping intact a precarious balance in the family."[1] The three-way conversation on Tenth Street, with the double agent present, obviously impressed the painter, who years later recounted the scene to writer and

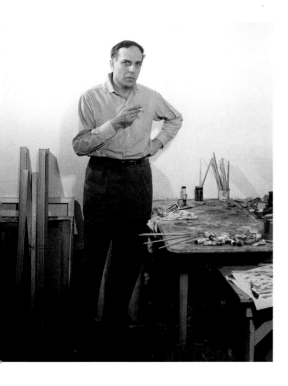

Philip Guston at his Tenth Street studio, c. 1952.
Courtesy The Estate of Philip Guston

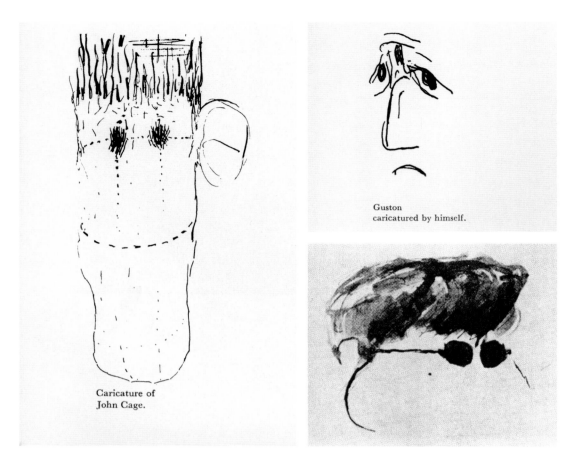

Caricature of
John Cage.

Guston
caricatured by himself.

Guston's caricatures of John Cage, himself, and Morton Feldman, reproduced in Feldman, "Philip Guston: The Last Painter," *Art News Annual* 31, 1966. Courtesy The Estate of Philip Guston

critic Jan Butterfield: "Cage and Feldman were in my studio, in 1951 or 1952, and I had just done what were probably the sparest pictures of all. I think one painting just had a few colored spots on it and lots of erasures, and so on. Well, anyway, that one picture had just been finished, and Cage was very ecstatic about it, and he said, 'My God! Isn't it marvelous that one can paint a picture about nothing!' and Feldman turned to him and said, 'But John, it's about *everything*!'"[2]

Was Cage referring to an imaginary void, a point of departure or arrival? Does nothing signify an existential condition—the base plan of human existence—even death? Is nothing something to be feared and deflected or graciously accepted without fanfare? Could it be a material thing, like the blank page of a musical score or a pristine canvas before creative acts intervene? How would an artist, like Guston, describe nothing? As an anxious state of expectation, a situation humming with possibility but potentially stymied by doubt? "Nothing," Feldman declared in his article on Guston, "is not a strange alternative in art. We are continually faced with it while working. In actual life, this experience hardly exists."[3] Would Cage agree? The space of nothing remains inert, silent until something else fills the gap. Between the space of nothing and the action of something, everything is possible.

Watershed events sometimes occur in unlikely places. In the lackluster loft at 39 East Eighth Street, Cage stood before an unsuspecting audience to read from a typed, score-like manuscript, the opening lines of which are stunning (see p. 39):

I am here , and there is nothing to say .

 If among you are those who wish to get somewhere , let them leave at any moment . What we re-quire is silence ; but what silence requires is that I go on talking .

This was no ordinary lecture for sure.[4] There was no discernable narrative, storyline, or thesis. Words and phrases were buffered by what must have seemed like vast pauses. It is likely that one recording of Cage reciting "Lecture on Nothing," probably made in his Eighteenth Street loft during the 1980s, exists.[5] Listening to it so many years later, one hears his matter-of-fact rubato, interspersed with poignant silences that punctuate the text like portals to vectors unknown. How did the original audience react to a text that circled back on itself with the provocative refrain, "If anybody is sleepy let him go to sleep"? One can imagine mounting befuddlement as Cage carried on, even after his friend Jeanne Reynal got up halfway through the performance and screamed, "John, I dearly love you but I can't bear another minute!"[6]

Bouncing off the minds of artists

If there were lessons, artistic or life-related, to be gleaned from Cage's lecture, what might these have been? The Johnny Appleseed–like character, roving among bohemians hell-bent to make art their own way, sowed the seeds of silence like a Zen master who expects nothing and encounters extreme skepticism. How might a curious artist respond to this kind of proposition? Being a composer, Cage instinctively understood that silence wasn't simply sound's passive partner. The nothingness that surrounds silence assumes dynamic form and character depending on its context. Cage's self-proclaimed "sermon" on listening, *4'33"*, performed by the pianist David Tudor at the Maverick Concert Hall in Woodstock on August 29, 1952, reinforced the point with striking audacity—to an equally befuddled audience (see p. 45).[7] Silence enables other sounds and figures to be heard or seen. In the absence of silence, structure dictates, like a one-dimensional plane of vision or a solipsistic conversation with the self. Cage scored silence as an invitation to hear beyond the prescribed.

Silence probably seemed like a quixotic calling card to the vociferous crowd that attended the lectures, panels, and performances at the artists' social hall known

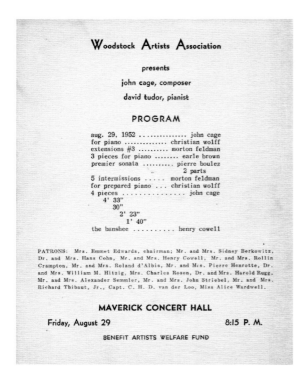

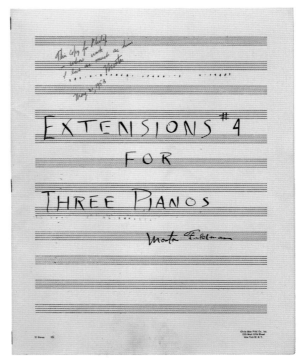

Program of the premiere concert of *4' 33"*, August 29, 1952, Woodstock, New York. 8⁷/₁₆ x 6⁷/₁₆ in. (21.4 x 16.4 cm). Courtesy John Cage Trust, Bard College, Annandale-on-Hudson, New York

Morton Feldman. *Extensions 4 (For Three Pianos)*, 1953. Score inscribed: This copy for Philip whose work I love as much as him—May 21, 1953. 14 x 11 in. (35.6 x 27.9 cm). Courtesy The Estate of Philip Guston

as The Club. But then, its nonconforming membership came to the downtown space on Wednesday and Friday nights anticipating some pretty arcane topics. They also came to socialize and unwind, argue about aesthetic matters, and, over the course of an evening, learn a thing or two. Like its plebian, libation-fueled neighbor the Cedar Tavern, The Club offered a safe haven for free expression at a time when any kind of radical discourse was suspect. The Club's programmatic agenda between 1950 and 1955—an eclectic menu that included lectures on existentialism, panels on Abstract Expressionism, and one-off talks about creativity, mythology, psychology, detachment, and involvement—flew in the face of conservative politics at the same time it empowered those individuals present to be who they wanted to be.[8]

Experimental music found a receptive audience at The Club through the efforts of Cage and Feldman. Appearances by contemporary composers such as Virgil Thomson, Pierre Boulez, and Edgard Varèse, along with lectures extolling the virtues of Zen, became staples.[9] Like existentialism, Zen offered the artistic soul alternate ways to navigate life's vicissitudes. If existentialism acknowledged the anxiety internalized by every vanguard artist living in a world without religion, patronage, or political protection and encouraged them to actively confront the situation on their own terms (something the critic Harold Rosenberg brilliantly distilled into a rationale for Action Painting), Zen advocated for a more mindful pace, the acceptance of

forces outside of one's control, and the ability to concede divergent points of view. By 1955, Zen had captured the imagination of many New York artists, particularly those fortunate enough to study with Daisetz Teitaro Suzuki during his stint at Columbia University.[10] As with any of the heady topics presented at The Club, it's hard to say what a painter or sculptor might have taken away. Artistic minds absorb substantive ideas in idiosyncratic ways. This may explain why William Barrett became so frustrated during his lecture on existentialism, and why his candid recollection, paradoxically, stands out as an exceptionally insightful assessment of how creative minds actually function: "I don't think I've ever spoken to a more attentive audience, yet I wasn't sure they heard what I said. That is, they listened to my words, but I'm not sure they heard their meaning. Ideas, abstract ideas, have a way of bouncing off the minds of artists at curious angles and ricochets that are a marvel to behold and a puzzle to try and follow."[11]

I really don't know what being an artist is

The fruitful exchange between Cage and Feldman during the early 1950s, when both resided at Cage's sixth-floor walk-up loft building at 326 Monroe Street, was matched by Feldman's ongoing conversations with Guston about the nature of abstraction, in both art and life. One can envision the scene at Bozza's Mansion (so named after the building's landlord) as musicians and artists came and went: the late-night sessions, constant shop talk, experimental writing, propitious appearance of graphic scores, and the realization that there was no such thing as a catastrophe when it came to the new music. What Cage and Feldman shared at this historical juncture was an enlightened attitude about sound and silence, whereby each claimed equal status on the acoustic plane. According to Feldman, sound "*in itself* can be a totally plastic phenomenon, suggesting its own shape, design, and poetic

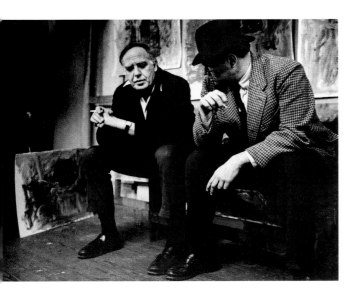

Guston and Feldman in Guston's studio, 1965.
Courtesy The Estate of Philip Guston

metaphor." Sound became raw material, just as paint was for the painter, something to be shaped, textured, and layered, and then projected into auditory space. Its sonic dimensions were manifold and not necessarily musical. Sounds could be as soft as a whisper or as bracing as a siren, in the case of *Williams Mix*, a dense collage of hundreds of analogue splices of chance-determined noises (see pp. 42–43). Sound could detonate only to decay into nothingness, or, as a ghost note or chord, barely exist at all. Compositions by Cage, Feldman, Christian Wolff, and Earle Brown, who formed the so-called New York School of composers, conceived as omnidirectional envelopes rather than horizontal progressions of metronomic notes, often mimicked the gestalt of abstract images by kindred artists.

The composers' preoccupation with silence and sound echoed the dialectical landscape of the period—a landscape animated in visual art circles by contentious debates around abstraction versus representation.[12] As the artistic epicenter migrated from Paris to New York after 1945, and as the new abstraction gained critical mass, most American artists felt compelled to choose sides. One's choice depended on one's aesthetic disposition; few had the mettle to straddle the middle ground. Being a musician sympathetic to abstraction, Feldman cast his lot early on with like-minded painters and sculptors, and he held tight to his convictions, even when it meant severing his friendship with Guston in the late 1960s, when the painter returned to figuration. "I mean, to me abstract painting and abstract type of music—that was it. There wasn't anything else," the composer confessed to an audience years later while introducing a performance of *For Philip Guston*. He also admitted that, in hindsight, he had been "the student in advanced middle age who was just thinking stylistically."[13]

Cage's dialectical disposition was more forgiving. Zen leavened his musical inclinations with a refreshing dose of detachment. Over time, as he continued to change, so did his notion of what being an artist meant. "I really don't know what being an artist is," he admitted to Feldman in 1966, during the first of five "Radio Happenings," conversations recorded live at WBAI in New York. "I have difficulty with the notion of roles. In other words, I don't want to play a role. I want to be, so to speak, what I am. If I am playing a role, I want to play it all the time. If I'm not playing a role, I don't want to play a role. But, what it was to be a composer doesn't seem to me any longer to be what it is now to be a composer—and I don't know what it is to be a composer now."[14] Cage's reluctance to take a definitive position on the role of the composer, coupled with his playful, Dadaesque spirit inclined toward chance, may explain why his influence persists. It may also explain why some of his earliest admirers—George Brecht, Merce Cunningham, Al Hansen, Richard Higgins, Jasper Johns, Allan Kaprow, Charlotte Moorman, Yoko Ono, Nam June Paik, and Robert Rauschenberg—preferred to mine the nebulous terrain between art and life and to extend the practice of art into social realms beyond the rarefied confines of the studio.

Cage eventually defected from the competitive, egocentric folds of the New York School, while Feldman eagerly joined its ranks.[15] With a generosity of spirit, Cage introduced Feldman to various artists whose aesthetic disposition mirrored his own. "A motif or quality indivisibly associated with the self, the 'I,'" is how Brian O'Doherty described Feldman's affinity to someone like Guston, and the same applies to the other artists selected for this exhibition.[16] Feldman held a more traditional notion of the artist, as someone "deep in thought," in control of his or her creative process, and immune to outside intrusions. What Feldman considered an intrusion, Cage saw as a possibility. Both approaches were entirely valid; it depended on what kind of artist you wanted to be.

"If a composer didn't have an artist friend, he was in trouble," Wolff recalled Feldman saying. Only about sixteen at the time, Wolff remembers, "there was a feeling that the break that the artists, in the various directions of abstraction, were making from previous (essentially representational) art, was parallel with the break that the composers were variously making from previous musical traditions (tonality, neo-Classicism, twelve-tone Serialism)."[17]

Like Guston, Feldman loved to talk. But he also knew how to listen, particularly in the company of painters, and this enabled him to become a trusted insider, a status he shared with perceptive critics and poets like Dore Ashton, Bill Berkson, Lawrence Campbell, Robert Coates, Clement Greenberg, Thomas Hess, Frank O'Hara, Harold Rosenberg, and Irving Sandler, who were then canvassing the beat. Feldman's copious writings, peppered with autobiographical anecdotes, are chock-full of insights. "The new painting," he observed, "made me desirous of a sound world more direct, more immediate, more physical than anything that had existed heretofore."[18] Initiated to full-bodied abstractions coming out of the cold-water flats south of Thirty-Fourth Street and the rustic cottages in the Hamptons, where many artists had studios, Feldman fleshed out the common ground with synesthetic instincts.

Guston introduced Feldman to the painter's world at an auspicious moment. They stood at the same philosophical crossroads: How to reinvent their respective disciplines by freeing themselves from the binds of historical precedents? Theirs were the equivalent of baby steps, deliberate but tentative, stroke by intuitive stroke, as they consciously pared down, limiting their palettes to a few colors (cadmium red medium, gray, white, green) or one or two instruments (cello or piano), and keeping the results simple. Neither knew exactly where he was headed. Mistakes and outright violations were inevitable; what mattered was staying in the moment, not second-guessing first moves, and persisting despite internal doubts and an indifferent public. On that first visit with Cage to Guston's studio, Feldman felt an immediate connection, which he recounted to O'Doherty: The painter has "form, . . . touch, frequency, intensity, density, ratio, color. To me this score [pointing at a ruled orchestral score in his Lexington Avenue apartment] is my canvas, this is my space. What I do is try to sensitize this area—this time-space."[19] A picture like *White*

Guston's studio table, Woodstock,
New York. Courtesy The Estate of
Philip Guston

Painting I, probably among the first works that Feldman saw, has the touch and
quietude of someone singing sotto voce (see p. 75). Guston's feather-light strokes
appealed to the composer, who appreciated their ephemeral grace. As Feldman
once put it, "Guston's drawings have the look of paintings, while his paintings have
the feel of drawings."[20]

Guston's arrival to abstraction came with a poignant realization, what he later
described as "a state of gradual dismantling." He felt like he was nowhere and had
nowhere to go. It took years for him to find his way through this crisis. Drawing
entered the gap as a way to short-circuit creative stasis. "Drawing is what locates,
suggests, imagines," Guston wrote more than twenty years later. [21] At this critical
juncture, it was a lifeline.

Guston drew prolifically during the 1950s. He preferred quill pens with bamboo
tips of various thicknesses; when loaded with black ink, they produced lines whose
intensity modulated depending on attack, duration, and pressure. Works from
this period display nuances of touch and texture that aren't always apparent in his
paintings. Guston's lines appear light and buoyant, but also in some instances
awkward, as though they'd been coaxed into being. There's very little cross-hatching;
modeling is practically nonexistent. Most lines remain open, veering away from
closure, avoiding recognizable shapes. Guston inscribed a drawing to Feldman
shortly after they met (see p. 72). The piece evokes an imaginary landscape (some-
thing that would have delighted Cage) populated by linear constellations (points,
dabs, lines) writ across the sky miles above the ground. The minimal image of
syncopated gestures surrounded by ambiguous space signaled a change for Guston,
as it did for Feldman, who visualized highly reductive soundscapes in graphic
scores for compositions bearing action-oriented titles like *Projection*, *Extension*,
and *Intersection* (see pp. 54–57, 60–67).

How do you know when a work is finished?

It's a shame that Guston wasn't at the table during the round-up sessions at Studio 35, for they would have intrigued him. The group that gathered behind closed doors for three consecutive days in April 1950 consisted mainly of painters, a few sculptors, and one token museum director.[22] Many of the participants knew each other from having taught at the small cooperative school Subjects of the Artist, which became known as Studio 35 after relocating to 35 East Eighth Street. For two seasons, from 1948 to 1950, they had lectured to eager students and a small general public on Friday nights about subjects of interest to "advanced artists." The Artists' Sessions held in 1950 at Studio 35, despite the diverging opinions expressed, signaled the solidarity of twenty-eight individuals candidly addressing the challenges of dedicating oneself to abstract art.

Issues pertaining to one's audience, the appropriateness of titles, the importance of tradition, the pros and cons of making money, and what binds the group together galvanized the sessions. The question "How do you know when a work is finished?" posed by moderator Robert Motherwell during the first day elicited varied responses. Some participants clearly knew when a work was complete and were quick to explain how; others had a harder time articulating definitive criteria and waxed poetic. Many of those present—William Baziotes, Louise Bourgeois, James Brooks, Willem de Kooning, Jimmy Ernst, Herbert Ferber, Adolph Gottlieb, Hans Hofmann, Ibram Lassaw, Norman Lewis, Richard Lippold, Seymour Lipton, Barnett Newman, Richard Pousette-Dart, and Ad Reinhardt—chimed in. Newman stated outright, "I think the idea of a 'finished' picture is a fiction." De Kooning, notorious for keeping a painting in flux, responded, "I refrain from 'finishing' it. I paint myself out of the picture, and when I have done that, I either throw it away or keep it." And Bourgeois, a sculptor who was then carving personages out of wood, offered, "I think a work is 'finished' when I have nothing to eliminate."[23] Consensus seemed beside the point. The question, however, raised others.

Lest we forget, in 1950 there was barely an audience for abstract art, and the galleries dedicated to this kind of work were few and far between. Even the artists had grave doubts about the viability of what they were doing. In a culture that generally tolerated art only if it was utilitarian, allegorical, or commissioned to flatter, the manifestations of maverick abstractionists were anathema. It's nearly impossible today to grasp the existential magnitude of the situation, now that all of the artists in question are gone, their once-perplexing canvases now appear as iconic images on postage stamps, and the global market for postwar American abstraction has skyrocketed.

Maybe de Kooning and Newman had it right when they recognized that one's creativity terminates only with death and that the process of painting is, in actuality, a continuous sequence of pictures none of which, technically speaking, is finished.

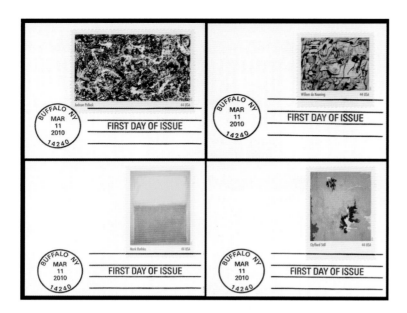

Abstract Expressionists, United States Postal Service commemorative postage stamps, first day of issue, March 11, 2010

(Feldman described Guston's non-objective stint in similar terms.) The important thing was to keep working. But times had changed and so had the art. Artists who had been employed during the Great Depression through the Works Progress Administration to produce representational murals and easel paintings were now sequestered in their studios painting non-representational pictures. But for whom? How could one rationalize isolation as a strategy to carry on? Was the act of working day in and day out, with no guarantee of a show or a sale, the only way to bolster one's self-esteem? Might this situation have had a bearing on de Kooning's reluctance to declare a picture finished—an aesthetic conceit driven by pathological uncertainty? In contrast to de Kooning's claustrophobic maelstroms, some works of the period were minimally conceived, like those of Guston and Joan Mitchell. And consider, too, the emblematic gesture of Franz Kline. Wouldn't a simple pictorial trope against a glacial white ground appear even less finished? In the act of painting abstractly, how does one know when to stop?

Too much instrument, I can't hear the music

Feldman may have appreciated the improvisational moxie of his painter friends, but he was underwhelmed by jazz musicians. The frenetic pulse of postwar Bebop sounded too dense to his ears, with too many rapid-fire solos over basic chord changes. "Too much instrument, I can't hear the music," the composer blurted out after one of the many jazz concerts at The Club.[24] In his head, he was hearing a different kind of music. Paring down the instrumentation, along with notes and chords, to emphasize the contours of a particular sound became his compositional signature. "I, too, like Boulez, wanted music to be an autonomous object," he wrote in 1972.[25] By then, he had written an extended series of graphic scores—each a

visual field populated by boxes containing numbers to indicate pitch, dynamics, and duration. Wolff remembers visiting Feldman's studio with Cage during the Bozza Mansion years and seeing a score-in-progress tacked up on the wall where he could "view it."[26] Such graphic scores changed how contemporary music was performed. Musicians were required to make choices while playing and according to the cues and directives given to them on paper. The degree of subjectivity implicit in a graphic score was, in part, a musical ode to the new abstraction.

Feldman courted his artistic clan at The Club and the Cedar Tavern, where he got to know Kline and Mitchell. Having survived as an artist through the Depression, Kline commanded respect, a status shared by de Kooning, who, likewise, was lionized by younger artists. Both were willing to talk and to listen, ready to defend abstract art and to reject anything that might compromise one's creative integrity. By the end of the 1950s, Kline's black-and-white abstractions were already selling for respectable prices through the Sidney Janis Gallery. He soon returned to using color. Janis apparently discouraged this development, urging him to stick with what was selling. The painter was infuriated, and in the fall of 1959, at the after-hours party for Robert Frank, Jack Kerouac, and Alfred Leslie's film *Pull My Daisy*, as he stood to toast Kerouac, Kline laid out the situation. The story is recounted by another composer, David Amram, who had written the film's soundtrack and knew many artists from his jazz gigs at the Five Spot. Kline could see that the scene was rapidly changing and that this low-budget black-and-white film captured the freewheeling ethos of a bygone time. Art was becoming big business; some artists were becoming famous. (In only three years, Kline would be dead and Andy Warhol would be having his first solo shows in New York and Los Angeles.) "Don't confuse fame and money with art," Kline intoned. "Rejoice in your fame if you get any. Spend your money if you get any. But don't ever forget what our job is. Don't forget we're in this for *life*!"[27]

What mattered most to Kline was "the integrity of the creative act," Feldman declared in his reminiscence about Eighth Street.[28] The painter's return to color, through a series of works on paper and collages, would have presented a compositional challenge, not unlike the addition of instruments to a score previously graced by silence. But Kline was surely up to the task; his last paintings are feats of brilliant orchestration. O'Doherty observed, "Silence had a curious figure-ground relationship in Morty's music, sometimes figure and sometimes ground."[29] The same could be said about Kline's robust abstractions, the calligraphic character of which echoed Asian brush painting and demanded the same rigorous training (see pp. 81–83).[30] Like a musician practicing scales or a solo, Kline rehearsed on paper, where ideas could be fleshed out and refined, or, if need be, rejected. By the time he approached the canvas, with a loaded brush in hand, he had a deliberate sense of purpose. The fluid, phase-shifting marriage between black and white, sound and silence, was noted early on by Tom Hess, shortly after Kline's breakout show at the Charles Egan Gallery: "His whites are often of equal, if not greater importance than

the blacks, for they are only superficially quiescent."[31] After Kline's death, Feldman honored his friend by including his work, along with works by five other painters, in an exhibition in Houston and by dedicating a magisterial composition to him.[32]

The Club also hosted wild parties. Reading Pavia's journal, one gets the impression that the post-opening parties, in particular, were Dionysian: "The floor at The Club would bounce up and down so obviously that the architects who used a pound per square foot mentality would leave the premises early and sheepishly. It was not just animal energy, but something wilder coming from each pair of feet bouncing vertically into non-history." On one occasion Pavia remembered, "Kline would dance with Mitchell until they rolled on the floor dancing horizontally."[33]

Mitchell cut her artistic teeth at The Club, going to Wednesday-evening round-tables and Friday-evening panel discussions as early as 1950 and soon after became a member, one of the few female artists invited to join. Once there, she found her voice. "Women learned how to flex their muscles at The Club," Pavia recalled. "Where else could a woman have a chance to talk on art or heckle a man on art? Where else could a woman get up and tell a large male audience, 'You are wrong!' Where else but at the Club could Elaine de Kooning, Mercedes Matter, Rose Slivka, Cynthia Navaretta, and Joan Mitchell tell us all off? Nowhere else."[34] Certainly, it's easier to accommodate difference when everyone faces similar hardships and the stakes aren't so high.

Mitchell made lifelong friends at The Club, Kline among them. She visited his Ninth Street studio beginning in 1950, and judging from the Arthur Swoger photograph taken at the Cedar Tavern seven years later, she continued to relish his presence. Fifteen years Mitchell's elder, Kline was someone she looked up to as a

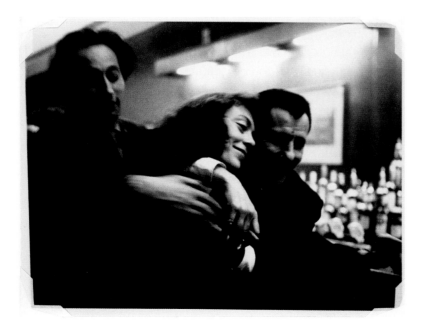

Arthur Swoger. *Norman Bluhm, Joan Mitchell, and Franz Kline*, 1957. Gelatin silver print, image 10½ x 13¾ in. (26.7 x 34.9 cm), sheet 11 x 14 in. (27.9 x 35.6 cm). Museum of Art, Rhode Island School of Design, Providence. Museum Acquisition Fund, 2003.12.1

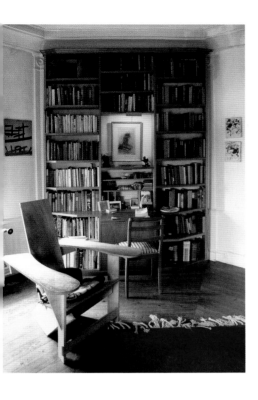

Joan Mitchell's library in Vétheuil, August 1983.
Collection Joan Mitchell Foundation Archives

surrogate, art-world father. She even traded five of her own paintings for a small untitled canvas by Kline, which occupied a prominent place in her library at Vétheuil, France.[35] Being introduced early on to Kline's courageous abstractions (as well as those of de Kooning and Hans Hofmann) inspired Mitchell to tackle her own. Although initially she played it safe by adopting a post-Cubist matrix, by 1953 she was stretching out with more confidence, painting evocative images like *Rose Cottage* with rigorous dabs, bleeds, and strokes offset by lighter passages of blue and gray (see p. 85). In just a few more years, she was painting with even greater assurance, as her canvases increased in size. In some works from the mid-1950s, agile strokes feathered out across unprimed canvas evoke the incisive moves of a figure skater, relaxed and graceful. But there are times when her gestures appear tight and compacted, fragmented and frenzied. The fluctuation between these two approaches is fascinating. When delicate strokes dominate, a serene sense of rightness pervades the work, recalling Guston's facture and interstitial space. Perhaps Mitchell was in attendance at The Club on the Wednesday evening when Guston talked about "brushstrokes" and about trusting one's instincts to leave well enough alone.

Between 1958 and 1959, Mitchell conceived some of her most minimal compositions, with marksman-like skeins and swatches of blacks, yellows, reds, and greens. During this time she saw Guston's current efforts in a solo show at the Sidney Janis Gallery, rented a studio in Paris at 10 rue Frémicourt (where she lived with the painter Jean-Paul Riopelle), and sailed the Mediterranean with Pierre and Patricia Matisse. Whatever the circumstances, she was on a roll, using wider

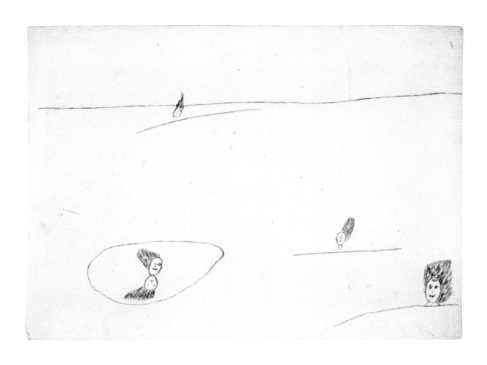

Louise Bourgeois. *Untitled*, 1943. Ink
on paper, 9 x 12 in. (22.9 x 30.5 cm).
Collection Saint Louis Art Museum

brushes and laying down paint decisively. Her works at this time declared space impressively. She wanted them to breathe, and they do so effortlessly. One thinks of Kline's later, more elaborate calligraphy. Mitchell had learned to lay back, to let her first intuitions determine the image. Stroke to stroke, color to color, space to form, the tremulous beauty of these canvases echo Feldman's score *Something Wild in the City: Mary Ann's Theme*, from 1960. Both deploy reductive measures and end up soaring.

Feldman's most intimate friendships tended to be with painters. Shortly after moving into Bozza's Mansion, Cage introduced him to the sculptor Richard Lippold, whose delicate, snowflake-like constructions appealed to him. But in general Feldman's interest in three-dimensional objects was peripheral. Perhaps the sculpture he encountered veered too close to representation. Sculptors naturally gravitated to the figure as a stepping stone to abstraction. They also navigated a different set of challenges. Welding or modeling steel or wood was not the same as wielding a brush loaded with paint. It was far easier to dream on paper. Sculptors would be the first to admit that their commitment to abstraction and color had a lot in common with painting. But there was no getting around sculpture's formidable mass and its humanistic associations when conceived as a monument. Such baseline differences led to fractious arguments between painters and sculptors—at the Artists' Sessions, during panels at The Club, and even while drinking at the local watering hole. Still, when it came to visualizing space metaphorically, they all shared the liberating potential of that perspective.

"Silence is a subject that interests me tremendously," Bourgeois told teacher and critic Robert Storr in 1983. "The length of the silence, the depth of the silence,

the irony of the silence, the timing of the silence. The hostility of the silence. The shininess and love of the silence."[36] Bourgeois was no stranger to the palpability of silence. Her earliest years in America, after she moved from Paris to Easton, Connecticut, with her art-historian husband Robert Goldwater, were a difficult time of adjustment. Living in suburbia, in a ranch house with three young children, she felt alienated, missing her family and friends back home. Some of the first works on paper she made, shortly after her arrival, reflect her quandary: bobbing heads, like buoys, are scattered across a landscape or seascape, or in another image, tears emanate from closed eyes, like lifelines to loved ones now far away. In these and other "nostalgia pictures" from the late 1940s and 1950s, the landscape functions as a nondescript terrain, a buffer between people, and a spatial foil for the propagation of abstract forms. In the spaces between people and things, silence reigns.

At a time when most vanguard artists soft-pedaled biographical innuendo, Bourgeois, who began as a painter, posed questions about the genesis of a work of art to her peers at the Artists' Sessions. She wanted to know how others felt about the process of creation and what motivates the artist. Formal concerns were important to her, of course, but so were sociological and personal influences. She was very clear that for her making art was therapeutic, a way to deflect depression and to fill the void of silence. The many personages she carved for her first three solo exhibitions at the Peridot Gallery in 1949, 1950, and 1953 memorialized the living in the context of a white-walled gallery. How the personages were installed— their spatial orientation and number—was critical. "It wasn't just about individuals,"

Plate 3

Once a man was telling a story, it was a very good story too, and it made him very happy, but he told it so fast that nobody understood it.

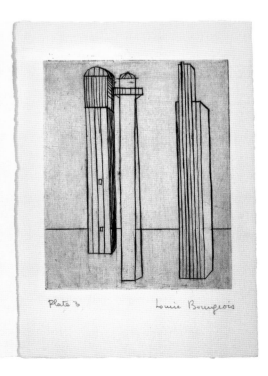

Louise Bourgeois. *He Disappeared into Complete Silence*, 1947, detail, page 3. Book of nine engravings and letterpress text on paper, each spread 10 x 14 in. (25.4 x 35.5 cm). Collection The Easton Foundation

she later explained to Michael Auping, "but relations between people. For the first show I made a social gathering of people. I tried to make them relate to each other."[37]

Relating to each other is exactly what each painted element in *The Blind Leading the Blind* does or does not do (see p. 27). Space, something Bourgeois correlated to silence, can unite but it can also divide. Space can blind, but it can also enlighten. It all depends on who is leading whom and the leader's intentions. At this point in the artist's life, silence signified a human condition: susceptible and vulnerable, easily undone, and prone to misdeed. When one disappears completely into silence, another is left abandoned and alone. The silence of alienation hovers around the architectural entities that inhabit *He Disappeared into Complete Silence,* which Bourgeois made at Stanley William Hayter's Atelier 17, in New York, during this formative period. Anecdotal texts about heartbreak, infidelity, cannibalism, and isolation anthropomorphize each image with uncanny sentiment.

David Smith had been welding his own personages for many years by the time he returned, in 1955, as a visiting artist at the University of Indiana in Bloomington, to the state of his birth. There he produced a series of ten forged vertical sculptures, each stamped with "Ind" on their base. His approach to sculpture, akin to drawing in space, had expanded his technical skills. In his able hands, steel was as pliable as clay, wrought into configurations that extended and commingled with space. The monolithic species produced in Bloomington, however, with the help of blacksmith LeRoy Borton, are something altogether different. Made from thin-gauge bars of heavily manipulated steel—cut, dented, bored, plugged, and textured—the *Forgings* are some of the most reductive sculptures Smith ever made (see pp. 89, 91).[38] A personage from 1951–52, *The Hero,* could be considered a precedent, given its frontal orientation and elongated torso, but ultimately its appendages— the enlarged eye-shaped head, small triangular breasts in a rectangular frame, and Constantin Brancusi–inspired base—produce a more complicated piece.

The *Forgings,* subtle in surface details but lacking substantial mass, appear vulnerable to encroaching space, in the same way a plaster waif by Alberto Giacometti does. Giacometti, the Achilles heel of postwar American abstraction, became the progenitor of another kind of figuration. His effigy-like personages, seen as a phenomenological battleground, infused monolithic sculpture with renewed possibilities. Jean-Paul Sartre, who introduced Giacometti's postwar work to an American audience, brought a philosophical perspective to his process based on existential notions of space: "[Giacometti] knows that space is a cancer on

Opposite, left: David Smith. *The Hero*, 1951–52. Steel, painted, 75 x 25½ x 11¾ in. (190.5 x 64.8 x 29.8 cm). Brooklyn Museum, Brooklyn, New York. Dick S. Ramsay Fund, 57.185; Courtesy The Estate of David Smith

Opposite, right: Alberto Giacometti. *Quatre Figures sur un Socle* (*Four Figures on a Pedestal*), 1950. Bronze, painted, 20¼ x 16 x 6⅜ in. (51.4 x 40.6 x 16.2 cm). Carnegie Museum of Art, Pittsburgh, Pennsylvania. Gift of Mr. and Mrs. Henry J. Heinz II, 55.45

being, and eats everything; to sculpt, for him, is to take the fat off of space; he compresses space, so as to drain off its exteriority."[39] Layering and dismantling plaster dust from a metal armature isn't the same as forging bars of steel, but the metaphorical implications of space acting as a cancer on being helps to explain the ambivalence of Smith's lean entities.

Smith once described drawing as "the life force of the artist," a statement Guston surely would have endorsed. Drawing enabled Smith to generate a steady stream of ideas without having to worry about how any one of them actually might get made. Marking paper was a reprieve from the blazing torch, the Promethean struggle with heavy metals that took place in the Terminal Iron Works, the cinder-block studio he built in upstate New York, at Bolton Landing. During the 1950s, Smith's experimentation with egg ink was a natural outgrowth of his search for a medium responsive to the nuances of spontaneous gesture. In an extended series of works on paper executed with soft sable brushes, at the same time as the *Forgings*, vertical forms brushed on one next to the other, with spaces in between, clearly emulate the stance and posture of three-dimensional analogues. The

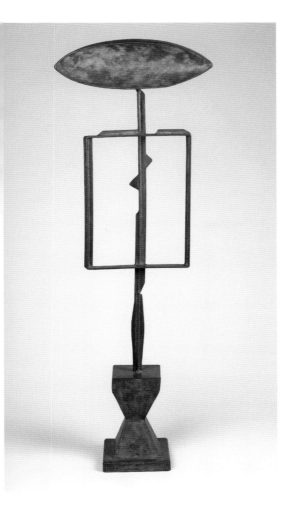

character of the image changes, however, in a horizontal format with brushstrokes that appear less anthropomorphic (see pp. 90, 92–95). Except for differences in dimension, Smith never drew distinctions between sculpture and painting (even after a critic like Clement Greenberg declared them mutually exclusive). When a dense pattern of strokes nearly obscures the paper, an affinity with painterly abstraction is noteworthy.

Veils of darkness, streaks of light: images of nothing or of everything? A brush loaded with ink glides spontaneously across the paper, leaving intermittent traces, like electromagnetic static, streaks that read as space and space that beams as silence. Are we looking at images of pure consciousness? Does the glimmer of white between bands of black suggest a creative mind open to mistakes, imperfections, unexpected intrusions? Smith's poetic gesticulations bring us back to Cage, to the "Lecture on Nothing," to a text riddled with gaps and silences that interrupt concentration and refocus attention. In one of the "Radio Happenings," Cage describes an imaginary concert, during which sounds from a radio bleed through an open door. He uses the situation of a room, a radio, and an open door metaphorically to question the notion of perfection and the sanctity of the self, knowing that to acknowledge sights and sounds outside of one's self-determined world enables an abundance of possibilities.

The author thanks Laura Kuhn and Pamela Hatley for reading this essay and for their editorial recommendations.

Notes

1. Morton Feldman, "Philip Guston: The Last Painter," *Art News Annual* 31, 1966, 98; reprinted in B. H. Friedman, ed., *Give My Regards to Eighth Street: Collected Writings of Morton Feldman* (Cambridge, Mass.: Exact Change, 2000), 37.
2. Clark Coolidge, ed., *Philip Guston: Collected Writings, Lectures, and Conversations* (Berkeley: University of California Press, 2011), 294.
3. Feldman, "Philip Guston: The Last Painter," 37.
4. Perhaps it's fitting that the question of when and where Cage first delivered his lectures on "Nothing" and "Something" continues to confound biographers and historians; see Kay Larson, *Where the Heart Beats: John Cage, Zen Buddhism, and the Inner Life of Artists* (New York: Penguin Press, 2012), 216–39.
5. Cage recorded this version of "Lecture on Nothing" on a cheap cassette recorder. He was probably in his seventies, judging from the tenor of his voice, and taking stock during a quiet moment in an otherwise busy schedule.

6. John Cage, preface to *Silence: Lectures and Writing by John Cage* (Middletown, Conn.: Wesleyan University Press, 1961), ix.
7. In response to a critical letter from Christian Wolff's mother, who had seen the program before its performance on April 9, 1954, at the Carl Fischer Concert Hall at 165 West Fifty-Seventh Street, Cage wrote to better explain his motives; see Letter to Helen Wolff, in Laura Kuhn, ed., *The Selected Letters of John Cage* (Middletown, Conn.: Wesleyan University Press, 2016), 176–78.
8. Philip Pavia, *Club without Walls: Selections from the Journals of Philip Pavia*, ed. Natalie Edgar (New York: Mid March Arts Press, 2007); see pages 158–78 for a listing of the programs presented between 1950 and 1955.
9. In his summary for 1952, Pavia wrote, "We found our name: Abstract Expressionism. New Elements were invading The Club: John Cage and Zen thinking, Frank O'Hara and the new poets"; see Pavia, *Club without Walls*, 172.

10. Suzuki arrived in New York during the summer of 1950. He first lectured at Columbia University in March 1951, and then taught classes there from the spring of 1952 until 1957. His students included Cage, Guston, Ibram Lassaw, and Ad Reinhardt; see Ellen Pearlman, *Nothing and Everything: The Influence of Buddhism on the American Avant-Garde, 1942–1962* (Berkeley: Evolver Editions, 2012), 1–25, and Kyle Gann, *No Such Thing as Silence* (New Haven: Yale University Press, 2010), 102–6.

11. William Barrett, *The Truants: Adventures among the Intellectuals* (New York: Anchor Press/Doubleday, 1982), 133. Invited by Elaine de Kooning, Barrett, who taught philosophy at New York University and wrote for *Commentary*, spoke at The Club on June 22, 1950. Pavia later described the event in his journal as a "tough evening" (*Club without Walls*, 159). Barrett would return to The Club the following year to speak about Martin Heidegger.

12. For an enlightened discussion on how dialectical discourse seeped into the intellectual fabric of the New York scene after 1945, see Jed Perl, "The Dialectical Imagination," *New Art City* (New York: Alfred A. Knopf, 2005), 63–86.

13. Feldman, remarks before a performance of *For Philip Guston* delivered at the Roy O. Disney Music Hall, California Institute of the Arts, Valencia, February 21, 1986; reprinted in *Give My Regards to Eighth Street*, 197.

14. "Radio Happening I," July 9, 1966, *John Cage and Morton Feldman, Radio Happenings: Conversations/Gespräche*, transcribed by Laura Kuhn, translated by Gisela Gronemeyer (Cologne: MusikTexte, 2015), 28.

15. Cage's defection from the New York School was both complicated and fascinating; see Caroline A. Jones, "Finishing School: John Cage and the Abstract Expressionist Ego," *Critical Inquiry* 19, summer 1993, 228–65.

16. Brian O'Doherty, "Morton Feldman," *The New York Times*, February 1964; reprinted in *Brian O'Doherty, Object and Idea: An Art Critic's Journal 1961–1967* (New York: Simon and Schuster, 1967), 100.

17. Christian Wolff, e-mail statement to the author, October 24, 2016.

18. Morton Feldman, "Liner Notes," *Kulchur* 2, no. 6, summer 1962; reprinted in *Give My Regards to Eighth Street*, 5.

19. O'Doherty, "Morton Feldman"; reprinted in *Object and Idea*, 99–100.

20. Feldman, *Give My Regards to Eighth Street*, 99.

21. Quoted from Guston's draft for "Ten Drawings," *Boston University Journal* 21, fall 1973; reprinted in Paul Schimmel, *Philip Guston: Painter 1957–1967*

(New York: Hauser & Wirth, 2016), 100.

22. Robert Goodnough, ed., "Artists' Sessions at Studio 35" (1950), *Modern Artists in America* (New York: Wittenborn Schultz, 1951), 9–22.

23. Ibid, 12.

24. Pavia, *Club without Walls*, 61.

25. Feldman, *Give My Regards to Eighth Street*, 110.

26. Wolff, e-mail statement to the author.

27. David Amram, *Offbeat: Collaborating with Kerouac* (Boulder: Paradigm, 2008), 82.

28. Feldman, *Give My Regards to Eighth Street*, 101.

29. O'Doherty, "Morton Feldman: The Burgacue Years," *Vertical Thoughts: Morton Feldman and the Visual Arts* (Dublin: Irish Museum of Modern Art, 2010), 72.

30. For a discussion of Kline's Asian influences through an association with Saburo Hasegawa, see Pearlman, *Nothing and Everything*, 113–28.

31. Thomas B. Hess, "Foreground and New York," *Abstract Painting: Background and American Phase* (New York: Viking, 1951), 137.

32. *Six Painters: Mondrian, Guston, Kline, De Kooning, Pollock, Rothko* opened at the University of St. Thomas in February 1967.

33 Pavia, *Club without Walls,* 64.

34. Ibid.

35. Mitchell obtained the Kline (an untitled 16$\frac{1}{8}$-by-13$\frac{3}{8}$ oil on paper from 1952) through Bud Holland, whose gallery, initially called Holland-Goldowsky, was located in Chicago. In 1963, she traded two paintings, for which she was credited $500. In 1965, the remaining balance of $1,500 was paid through a trade of three works. Another, larger Kline painting from 1954 was acquired through Eleanor Ward's Stable Gallery in lieu of money owed to the artist. Of the many artists whose works were then offered, as compensation, to Mitchell, she chose the Kline and a de Kooning. I thank Laura Morris, archivist at the Joan Mitchell Foundation, for providing me with this information.

36. Bourgeois, interview with Robert Storr, February 19, 1983; quoted in Frances Morris, ed., *Louise Bourgeois* (New York: Rizzoli in association with Tate Publishing, 2008), 270.

37. Bourgeois to Michael Auping, New York, October 25, 1996, in *Michael Auping: Thirty Years, Interviews and Outtakes* (Fort Worth and Munich: Modern Museum of Fort Worth in association with Prestel, 2007), 45.

38. For an excellent discussion of Smith's *Forgings*, see Hal Foster, "To Forge," *David Smith: The Forgings* (New York: Gagosian Gallery in association with Rizzoli, 2013), 11–17.

39. Jean-Paul Sartre, "The Search for the Absolute," in *Alberto Giacometti: Exhibition of Sculptures, Paintings, Drawings* (New York: Pierre Matisse Gallery, 1948), 2–22.

Louise Bourgeois (1911–2010)

The Blind Leading the Blind, 1947–49. Wood, painted red and black, 69½ x 69 x 23 in. (176.5 x 175.3 x 58.4 cm). Ed. 3/6

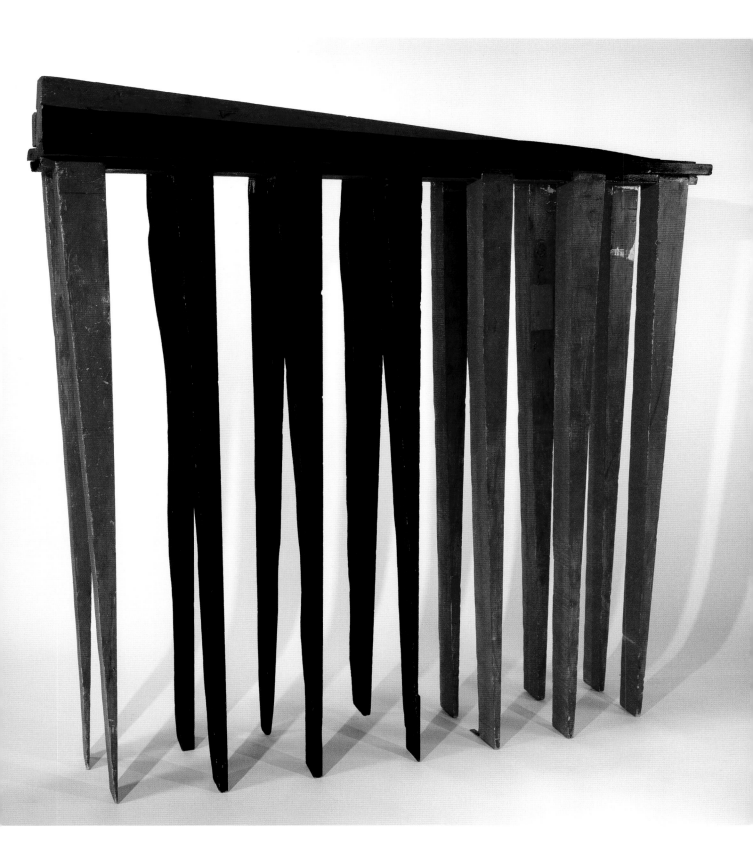

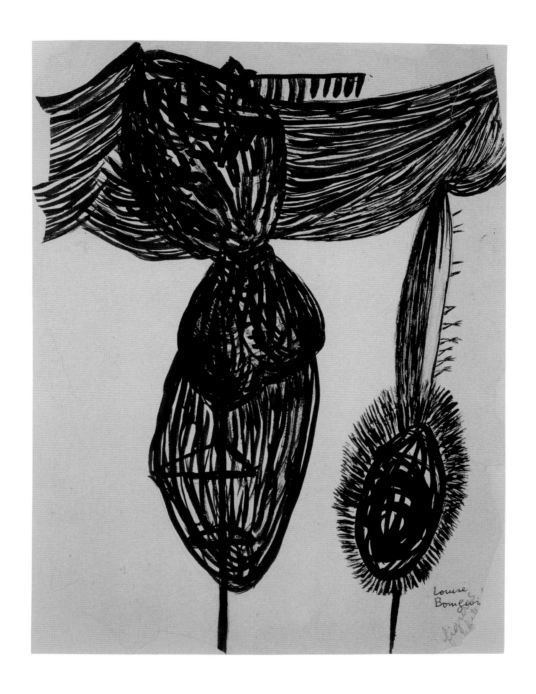

Figures Abstraites, 1947. Ink on tan paper, 10¾ x 8¼ in. (27.3 x 21 cm)

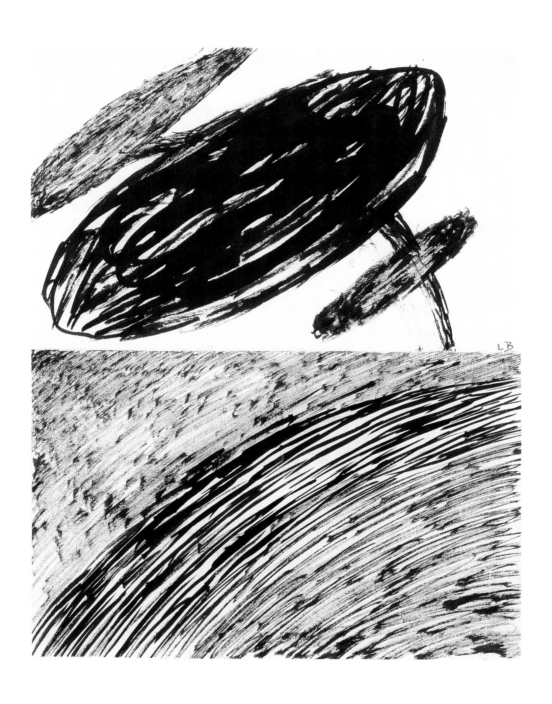

Untitled, 1949. Ink on paper, 10⅞ x 8½ in. (27.6 x 21.6 cm)

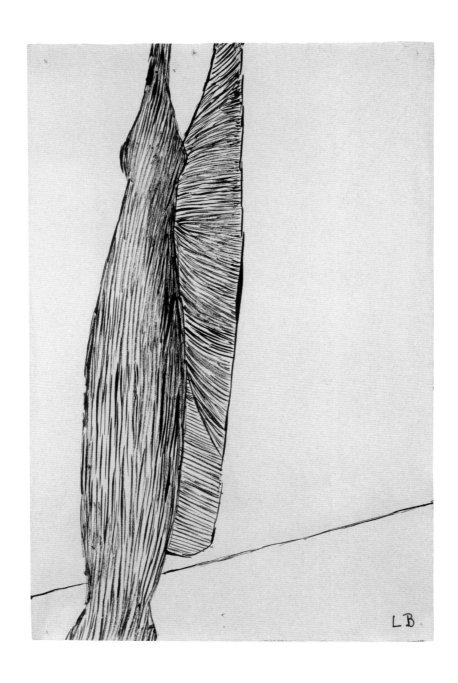

Untitled, 1949. Ink on paper, 8 x 5¼ in. (20.3 x 13.3 cm)

Opposite: *Breasted Woman*, 1949–50, cast 1989. Bronze, paint, and stainless steel, 54 x 3½ x 3½ in. (137.2 x 8.9 x 8.9 cm). Ed. 5/6 + 1 AP

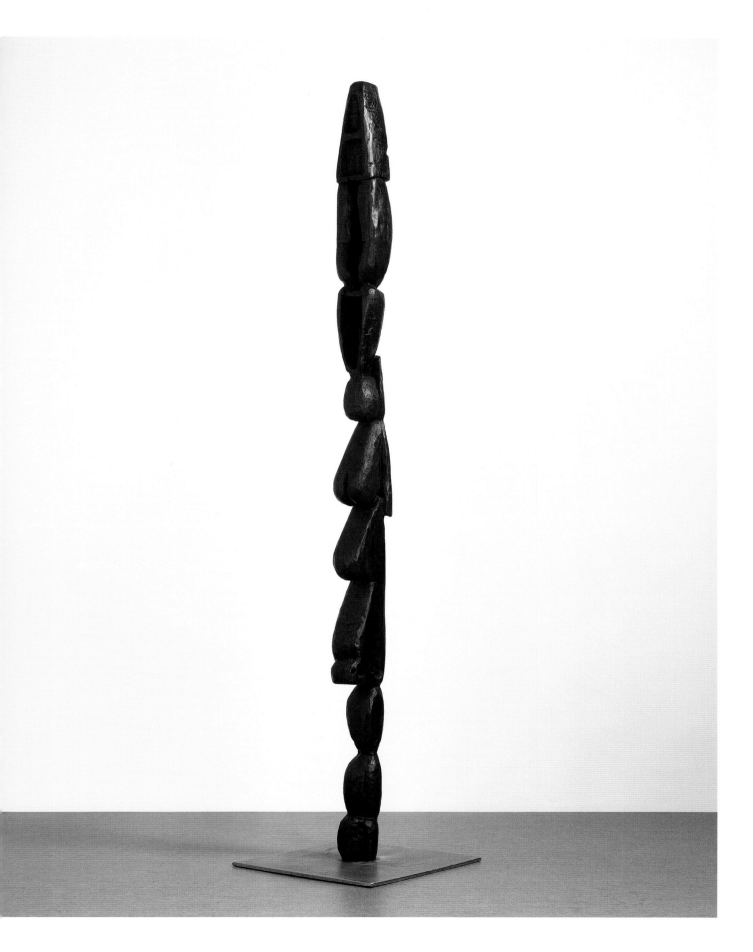

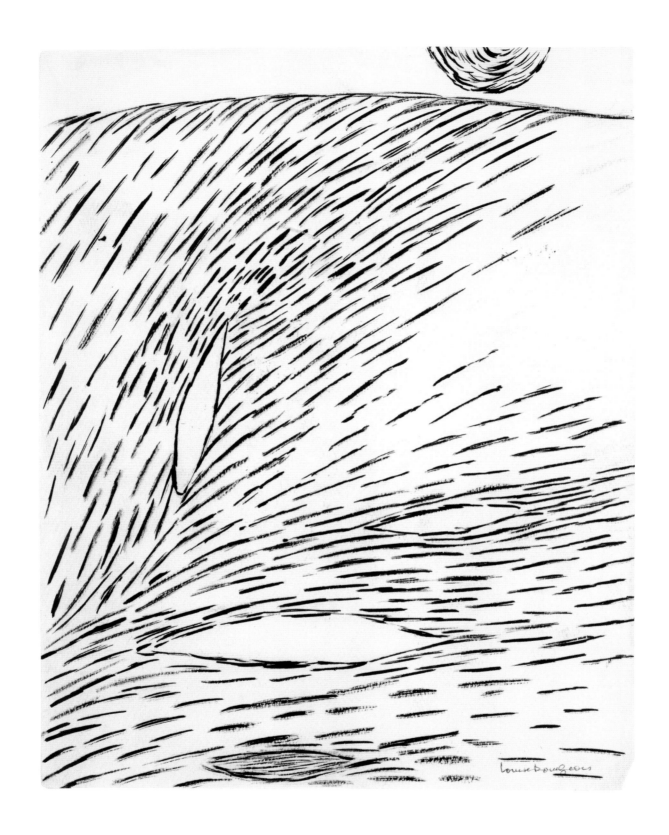

Untitled, 1950. Ink on paper, 14 x 11 in. (35.6 x 27.9 cm)

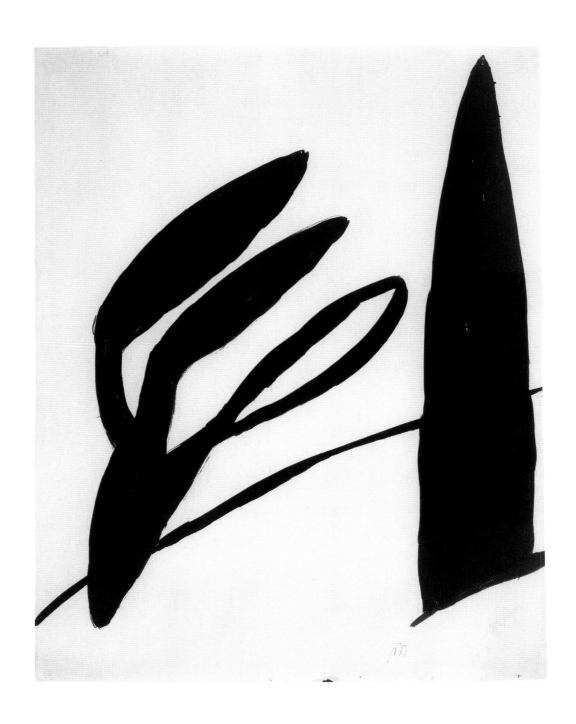

Untitled, 1950. Ink on paper, 11 x 8½ in. (27.9 x 21.6 cm)

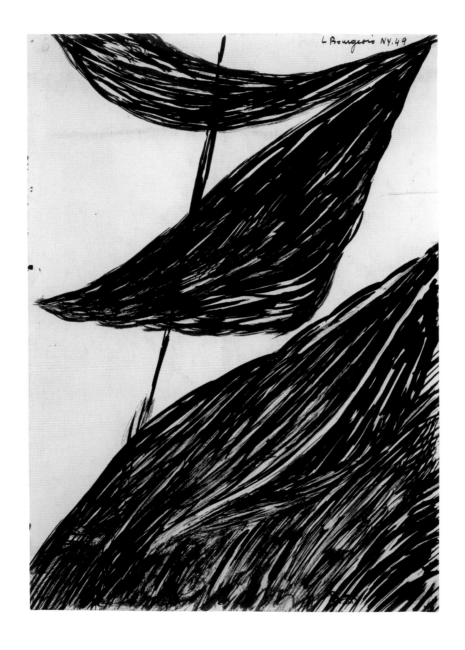

Untitled, 1949. Ink on paper, 10½ x 7¼ in. (26.7 x 18.4 cm). Verso: very fine drawing
one of my favorites [crossed out]

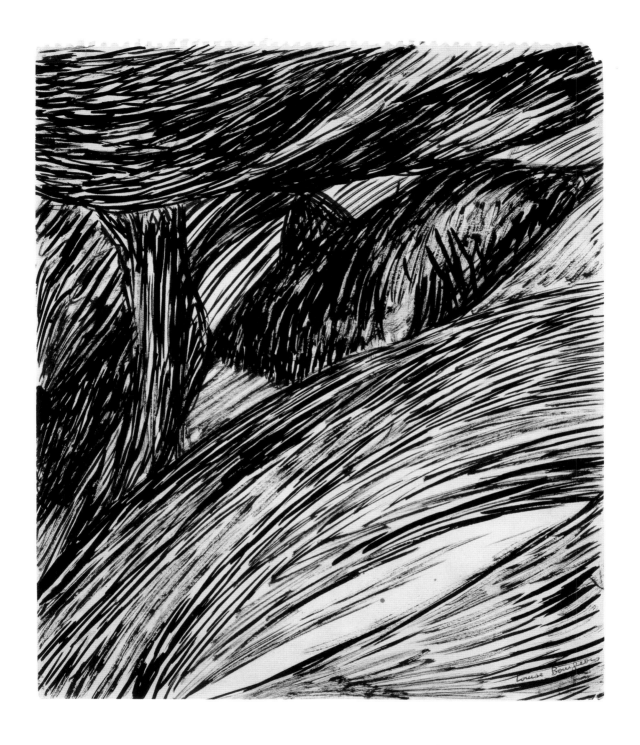

Untitled, 1950. Ink on paper, 11½ x 9¾ in. (29.2 x 24.8 cm)

Memling Dawn, 1951, cast 1992. Bronze, stainless steel, 62⅝ x 15 x 18 in.
(159 x 38.1 x 45.7 cm). Ed. 4/6 + 1 AP

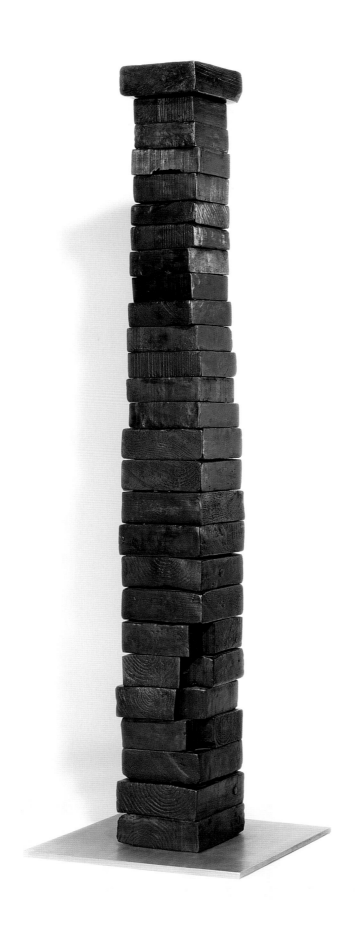

John Cage (1912–1992)

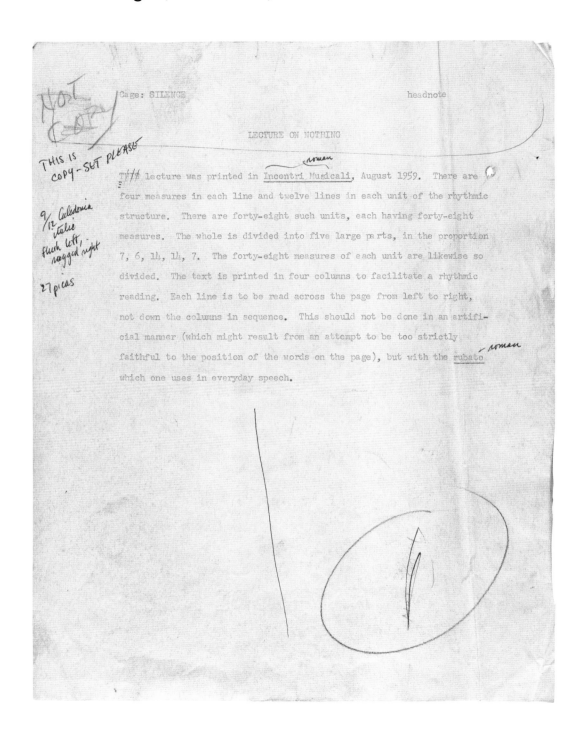

Cage: SILENCE headnote

LECTURE ON NOTHING

roman

Th/ß lecture was printed in Incontri Musicali, August 1959. There are
four measures in each line and twelve lines in each unit of the rhythmic
structure. There are forty-eight such units, each having forty-eight
measures. The whole is divided into five large parts, in the proportion
7, 6, 14, 14, 7. The forty-eight measures of each unit are likewise so
divided. The text is printed in four columns to facilitate a rhythmic
reading. Each line is to be read across the page from left to right,
not down the columns in sequence. This should not be done in an artifi-
cial manner (which might result from an attempt to be too strictly
faithful to the position of the words on the page), but with the rubato *roman*
which one uses in everyday speech.

(handwritten notes:)
NOT COPY

THIS IS
COPY—SET PLEASE

9/12 Caledonia
Italic
flush left,
ragged right

27 picas

"Lecture on Nothing," 1949. Corrected transcript, 8½ x 11 in. (21.6 x 27.9 cm).
Illustrated are Cage's headnote, first four sheets of lecture, and afternote

LECTURE ON NOTHING

```
I am here          ,          and there is nothing to say          .
                                                If among you are
those who wish to get somewhere          ,          let them leave at
any moment          .                    What we re-quire          is
silence          ;          but what silence requires
          is          that I go on talking  .
                                                Give any one thought
          a  push          :          it falls down easily
;          but the pusher          and the pushed          pro-duce          that enter-
tainment          called          a dis-cussion
          Shall we have one later  -                    ?
```

*

Note: 12th line is completely empty.

See P 128

```
Or          ,  we could simply de-cide          not to have a dis-
cussion          .                    What ever you like.          But
now                    there are silences          and the
words          make          help make          the
silences          .

                                        I have nothing to say
          and I am saying it          and that is
poetry          as I need it          .

          This space of time          is organized
.          We need not fear these    silences,--
```

*

Note: the 6th & 10th lines are empty.

```
we may love them       .                            This is a composed

talk              ,             for I am making it
        just as I make          a piece of music.         It is like a glass
    of milk           .                 We need the       glass
and we need the       milk                .    Or again   it is like an
empty glass                          into which                    at any
moment          anything                         may be poured
  .            As we go along      ,             (who knows?)
        an i-dea may occur in this talk                    .
                                 I have no idea     whether one will
            or not.              If one does,       let it.        Re-
                                     *
```

```
gard it as something  seen            momentarily      ,             as
though       from a window       while traveling       .
If across Kansas       ,              then, of course,    Kansas
  .            Arizona                      is more interesting,
almost too interesting,             especially  for a New-Yorker       who is
being interested  in spite of himself  in everything.      Now he knows he
needs          the Kansas in him       .              Kansas is like
nothing on earth      ,              and for a New Yorker  very refreshing.
It is like an empty glass,          nothing but wheat    ,              or
is it corn         ?                Does it matter which  ?
Kansas          has this about it:    at any instant,    one may leave it,
and whenever one wishes one may return to it.
                                     *
```

In keeping with the thought expressed above that a discussion is nothing more than an entertainment, I prepared six answers for the first six questions asked, regardless of what they were. In 1949 or '50, when the lecture was first delivered (at the Artists' Club as described in the Foreword), there were six questions. In 1960, however, when the speech was delivered for the second time, the audience got the point after two questions and, not wishing to be entertained, refrained from asking anything more.

The answers are:

1. That is a very good question. I should not want to spoil it with an answer.

2. My head wants to ache.

3. Had you heard Marya Freund last April in Palermo singing Arnold Schoenberg's Pierrot Lunaire, I doubt whether you would ask that question.

4. According to the Farmers' Almanac this is False Spring.

5. Please repeat the question/. /. /. /
 And again /. /. /. /
 And again /. /. /. /

6. I have no more answers.

WILLIAMS MIX for magnetic tape

John Cage

SOME EXPLANATIONS REGARDING THE SCORE OF THE WILLIAMS MIX:

This is a score for the making of music for magnetic tape. Each
page has 2 'systems' comprising 8 lines each. These 8 lines are
8 tracks of tape and they are pictured full-size, so that the
score constitutes a pattern for the cutting of tape and its
splicing. It has been found by experiment that various ways of
cutting the tape affect the attack and decay of the sounds recorded
on the tape. Therefor these are all indicated exactly when they
involve simple or double cuts across the tape. When the desired
cutting to be done exceeds this simplicity one sees in the score
a cross (in green pencil). It is then the business of the splicer
to freely cut the tape, even to 'pulverize' it, in a complicated
way. When arrows appear in the score on diagonal lines, this
refers to a way of splicing on the diagonal at the angle and in the
direction notated which produces an alteration in all the character-
istics of the recorded sound.

Within each enclosed shape, one may read a designation of the
sound to be spliced. These (all audible phenomena) are categorized
as A, B, C, D, E or F and according to whether the frequency,
overtone structure and amplitude are predictable or not, c or v.
Thus Cvvv (4th track, 1st system) is a sound of the category C
(electronically produced or 'synthetic' sounds) in which all the
three characteristics mentioned above are v or variable, i.e.
unpredictable. Cccc will be a sound of the same category, the 3
characteristics being c or constant, i.e. predictable.

When a sound is described as double, e.g. DcvcEccc, electronic
mixing has produced the combination. When a sound has an underlined
designation, e.g. A₁cccDccc, the A₁ part has been made into a
loop, thus bringing about a rhythmic pattern characteristic and then
electronically mixed with the D constituent.

Red dots indicate that the actual splicing was completed.

This score is written for tape travelling at 15 inches per second.
Therefor, each page is the score of 1 and one-third seconds. Thus
the 192 pages constitute the score of a piece only a fraction over
$4\frac{1}{4}$ minutes.

A : city sounds; B: country sounds; C: electronic sounds;
D : manually produced sounds, including the literature of music;
E : wind produced sounds, including songs;
F : small sounds requiring amplification to be heard with the others.

The library of sounds used to produce the Williams Mix numbers around
500 to 600 sounds.

COPYRIGHT © 1960 BY HENMAR PRESS INC., 373 PARK AVE. SO., NEW YORK 16, N.Y.

Williams Mix for Magnetic Tape, January 16, 1952. Holograph in black, green, orange pencil,
8⅝ x 11 in. (22 x 28 cm). Illustrated are Cage's instructions and first two sheets of score

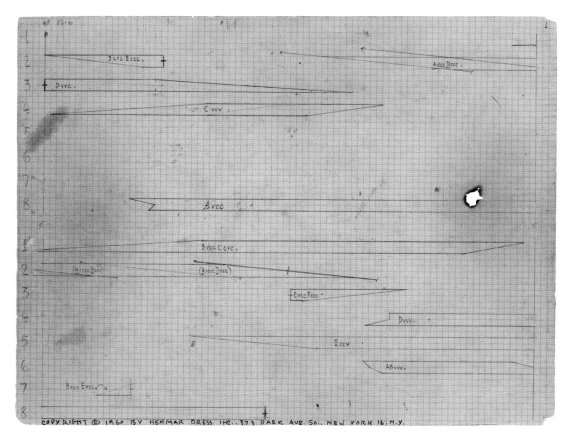

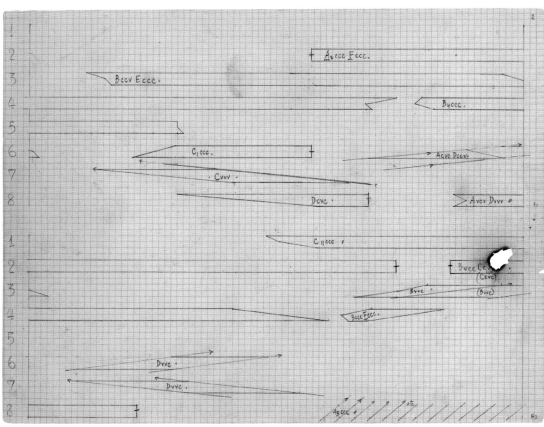

John Cage 43

```
                    I

                  TACET

                   II

                  TACET

                  III

                  TACET
```

NOTE: The title of this work is the total length in minutes and
seconds of its performance. At Woodstock, N.Y., August 29, 1952,
the title was 4' 33" and the three parts were 33", 2' 40", and 1'
20". It was performed by David Tudor, pianist, who indicated the
beginnings of parts by closing, the endings by opening, the key-
board lid. However, the work may be performed by any instrument-
alist or combination of instrumentalists and last any length of
time.

THE MOVEMENTS MAY
AFTER THE WOODSTOCK PERFORMANCE A COPY IN PROPORTIONAL
NOTATION WAS MADE FOR IRWIN KREMEN. IN IT THE TIMELENGTHS
FOR IRWIN KREMEN JOHN CAGE
OF THE MOVEMENTS WERE 30" 2'23" and 1'40". H

80"
223
1 40

4'33", 1952. Score, 8³⁄₈ x 6³⁄₈ in. (21.4 x 16.4 cm)

No. 6701

JOHN CAGE

ARIA

VOICE (any range)

JOHN CAGE

ARIA

VOICE (any range)

Sole Selling Agents:

C. F. PETERS CORPORATION

NEW YORK - LONDON - FRANKFURT

THE ARIA MAY BE SUNG IN WHOLE OR IN PART TO PROVIDE A PROGRAM OF A DETERMINED TIME-LENGTH, ALONE OR WITH THE FONTANA MIX OR WITH ANY PARTS OF THE CONCERT.

THE NOTATION REPRESENTS TIME HORIZONTALLY, PITCH VERTICALLY, ROUGHLY SUGGESTED RATHER THAN ACCURATELY DESCRIBED. THE MATERIAL, WHEN COMPOSED, WAS CONSIDERED SUFFICIENT FOR A TEN MINUTE PERFORMANCE (PAGE = 30 SECONDS); HOWEVER, A PAGE MAY BE PERFORMED IN A LONGER OR SHORTER TIME-PERIOD.

THE VOCAL LINES ARE DRAWN IN BLACK, WITH OR WITHOUT PARALLEL DOTTED LINES, OR IN ONE OR MORE OF 8 COLORS. THESE DIFFERENCES REPRESENT 10 STYLES OF SINGING. ANY 10 STYLES MAY BE USED AND ANY CORRESPONDANCE BETWEEN COLOR AND STYLE MAY BE ESTABLISHED. THE ONE USED BY MISS BERBERIAN IS: DARK BLUE = JAZZ; RED = CONTRALTO (AND CONTRALTO LYRIC); BLACK WITH PARALLEL DOTTED LINE = SPRECHSTIMME; BLACK = DRAMATIC; PURPLE = MARLENE DIETRICH; YELLOW = COLORATURA (AND COLORATURA LYRIC); GREEN = FOLK; ORANGE = ORIENTAL; LIGHT BLUE = BABY; BROWN = NASAL.

THE BLACK SQUARES ARE ANY NOISES ('UNMUSICAL' USE OF THE VOICE, AUXILIARY PERCUSSION, MECHANICAL OR ELECTRONIC DEVICES). THE ONES CHOSEN BY MISS BERBERIAN IN THE ORDER THEY APPEAR ARE: TSK, TSK; FOOTSTOMP; BIRD ROLL; SNAP, SNAP (FINGERS), CLAP; BARK (DOG); PAINED INHALATION; PEACEFUL EXHALATION; HOOT OF DISDAIN; TONGUE CLICK; EXCLAMATION OF DISGUST; OF ANGER; SCREAM (HAVING SEEN A MOUSE); UGH (AS SUGGESTING AN AMERICAN INDIAN); HA. HA (LAUGHTER); EXPRESSION OF SEXUAL PLEASURE.

THE TEXT EMPLOYS VOWELS AND CONSONANTS AND WORDS FROM 5 LANGUAGES: ARMENIAN, RUSSIAN, ITALIAN, FRENCH, AND ENGLISH.

ALL ASPECTS OF A PERFORMANCE (DYNAMICS, ETC.) WHICH ARE NOT NOTATED MAY BE FREELY DETERMINED BY THE SINGER.

FOR CATHY BERBERIAN MILANO 1958

Aria, 1958. Finished score, 7⅛ x 10¼ in. (18 x 26 cm), and digitized sound file.
Illustrated are cover, opening pages, and selected sheets of score

1

A-RISE!

NAPRASNO

DIROUHI

DI QUESTA TERRA

HAMPART-ZOUM

CONSCIENCE ET

3

BREATH—

BREATHE FORTH

GDE ONA

LA VIE

SPOKOÍNYOO VÁDZNOSTYOO ·Z·

I GO HAROOSTUTIUN

NEI BOSCHI DI
CONIFERE

COULD ENTER
YOUR HEART
NON TANTO
HOW SO?
GIOVANE

G·B·K·U

CHTO
NOVOGO
POKÁDZET

VIDIELA

FACILMENTE

E IO
SONO PER TE

NO OTHER WAY
DANS L'ESPACE
SO HELP

SI JUSTE

DVIDZÉNYA
BISTRI

5

IDYOT

O·A·K·HO·A

STVAYOOT
ETERNAL
LOOSIN

A·K·U

ON
PEKRASEN

7

17

ZAKRÍPA

(trill)

AVEC DES
MOYENS
TYPIQUES
ET SUPRÊMES
A·T·D·Z·U

LIKE FROM LIKE
O TCHOM DZE

19

LO SPAZIO

IL CANTO
·B·

NYET

AS WHEN HE
WAS WHEN
HE WAS
NOT

THE FIRST
SIGN:

O-

K·A·S

LEZVOV
T·O

DAPPRIMA
TOUJOURS EST-IL
QUE CE MOT D'UNE
LANGUE HUMAINE
G·L·N·T·B

A

A CALL TO LA
SOURCE
POSSIBLE

MINTCHEV

VELLUTATO
AS A
G·B·S·K·A

Morton Feldman (1926–1987)

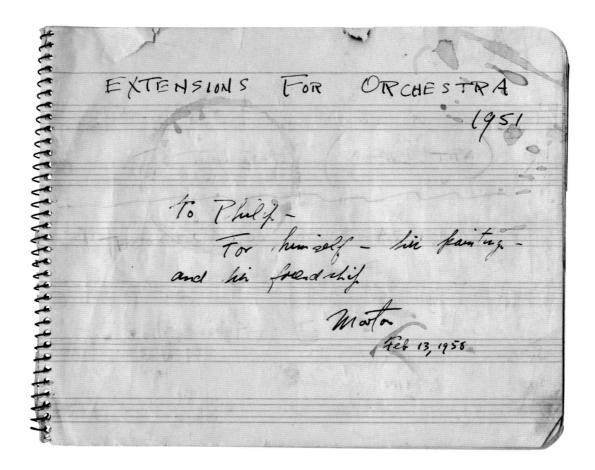

Extensions for Orchestra, 1951. Score, 7 x 8⅝ x ¼ in. (17.8 x 21.9 x 0.6 cm). Manuscript inscribed: Dedicated to Philip, Feb 13, 1958; To Philip/For himself, his paintings and his friendship. Illustrated are selected sheets of score

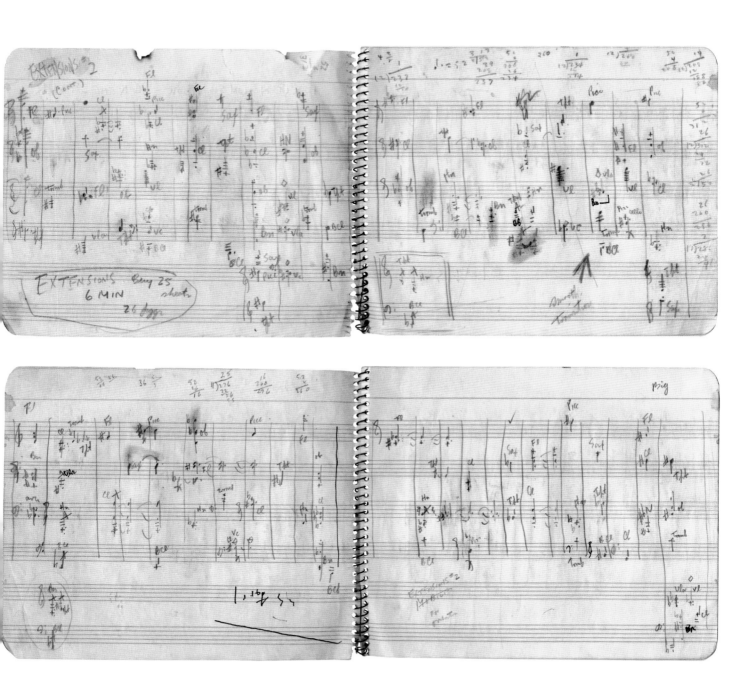

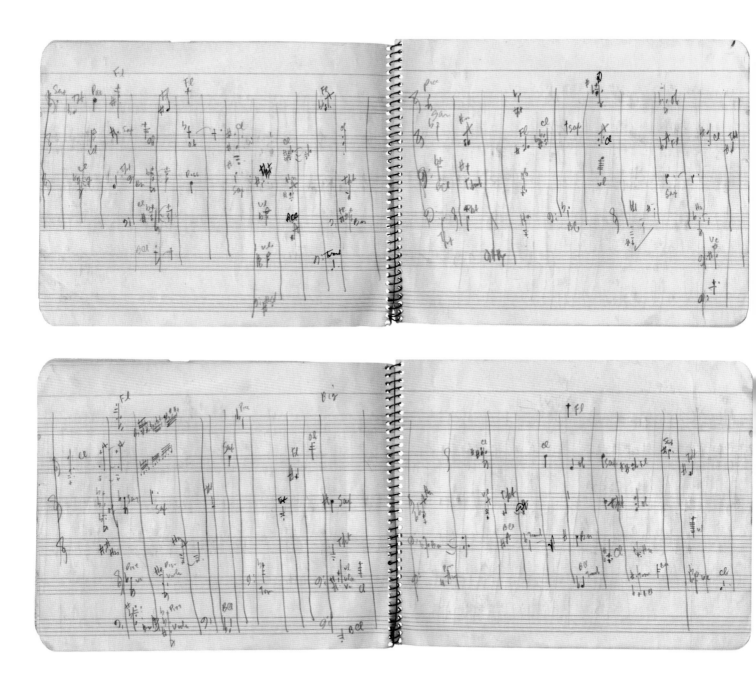

56

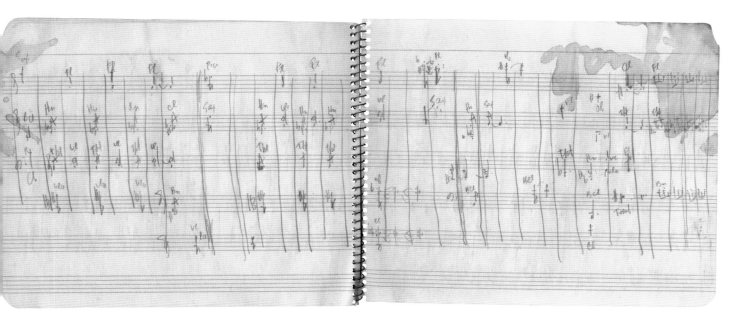

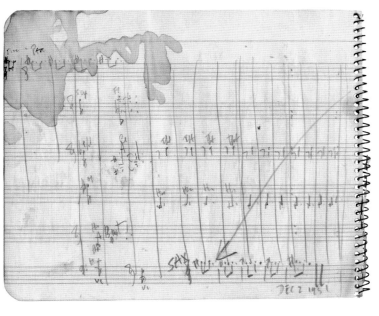

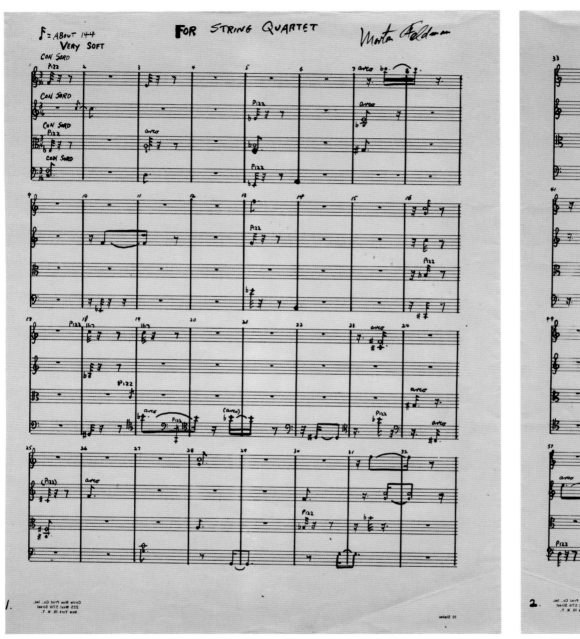
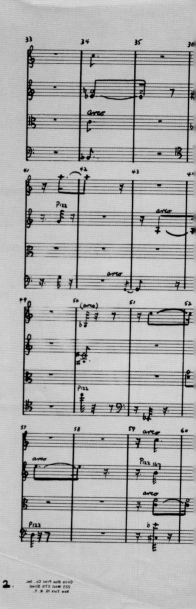

For String Quartet, April 10, 1956. Finished score, 14½ x 32½ in. (36.8 x 82.6 cm).
Inscribed: This composition is/dedicated to Philip/Guston whose/love and respect/without
which-/this work would/not be possible

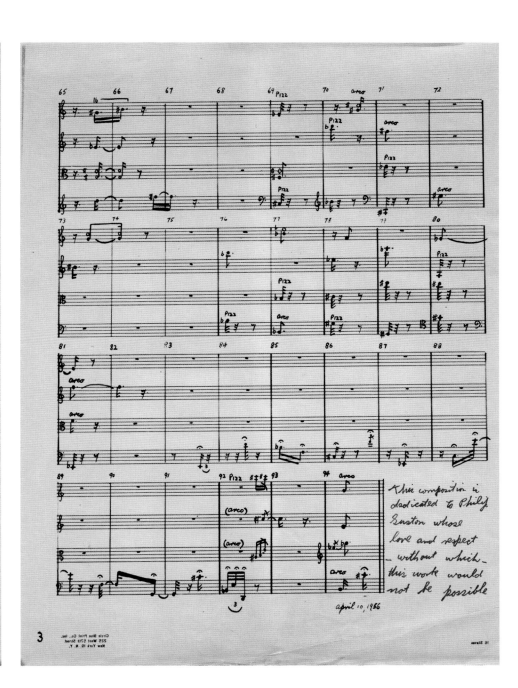

This composition is dedicated to Philip Guston whose love and respect — without which — this work would not be possible

april 10, 1956

3

No. 6945

FELDMAN

PROJECTION 1

Solo Cello

Projection I, 1950. Finished score, 8⅜ x 11⅛ in. (21.3 x 28.3 cm), and digitized sound file

PROJECTION 1

FOR SOLO CELLO

Morton Feldman

TIMBRE IS INDICATED: ◊ = HARMONIC; P=PIZZICATO; A=ARCO

RELATIVE PITCH (HIGH, MIDDLE, LOW) IS INDICATED: ⊔ = HIGH; ⊡ =MIDDLE;

⊓ = LOW. ANY TONE WITHIN THE RANGES INDICATED MAY BE SOUNDED.

THE LIMITS OF THESE RANGES MAY BE FREELY CHOSEN BY THE PLAYER.

DURATION IS INDICATED BY THE AMOUNT OF SPACE TAKEN UP BY THE

SQUARE OR RECTANGLE, EACH BOX (⌇ ⌇) BEING POTENTIALLY 4 ICTI.

THE SINGLE ICTUS OR PULSE IS AT THE TEMPO 72 OR THEREABOUTS.

6945

PROJECTION 1

Morton Feldman

1.

3.

2.

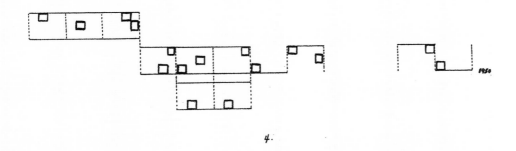

4.

No. 6960

FELDMAN

INTERSECTION 4

Printed in the U.S.A.

Intersection 4, November 22, 1953. Finished score, 8⅜ x 11⅛ in. (21.3 x 28.3 cm)

Each box is equal to MM 80. Each system is notated vertically
as regards pitch: high, middle, low. The player is free to
choose any dynamic and to make any rhythmic entrance within the
given situation. Numbers indicate the amount of sounds to be
played simultaneously (if possible). Sustained sounds, once
played, must be held at the same dynamic level to the end of the
given duration. All sounds are pizz. unless otherwise notated.
◊ har.; A arco; etc. etc.

INTERSECTION 4.

□ = 80

Morton Feldman

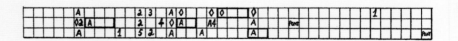

1.

Nov. 22, 1953

3.

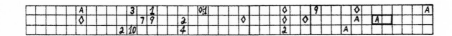

2.

Philip Guston (1913–1980)

Voyage, 1956. Oil on canvas, 72 x 76 in. (182.9 x 193 cm)

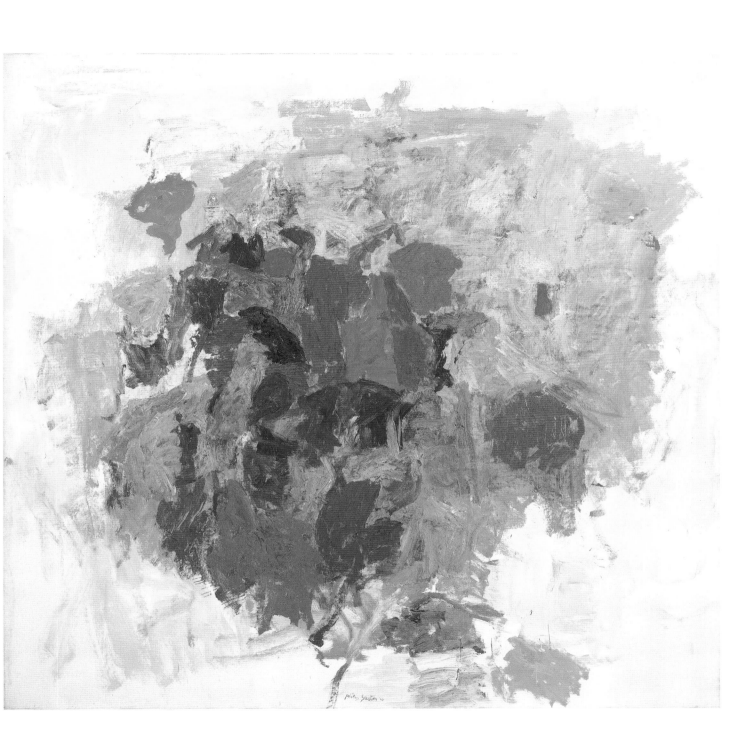

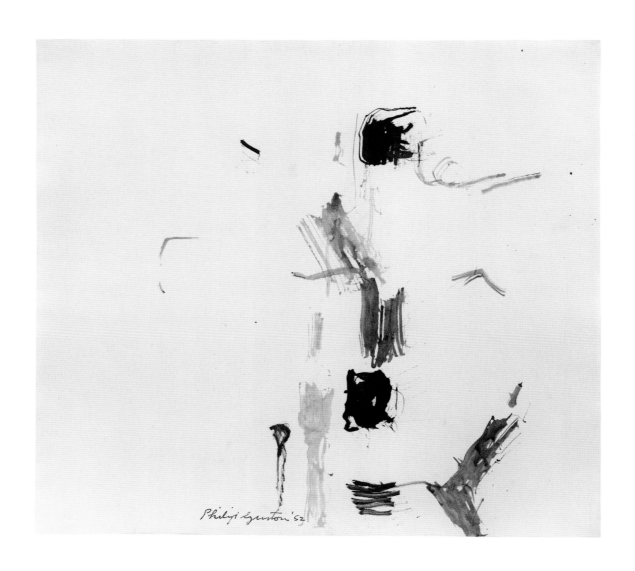

Untitled, 1952. Ink on paper, 18 x 19⅞ in. (45.7 x 50.4 cm)

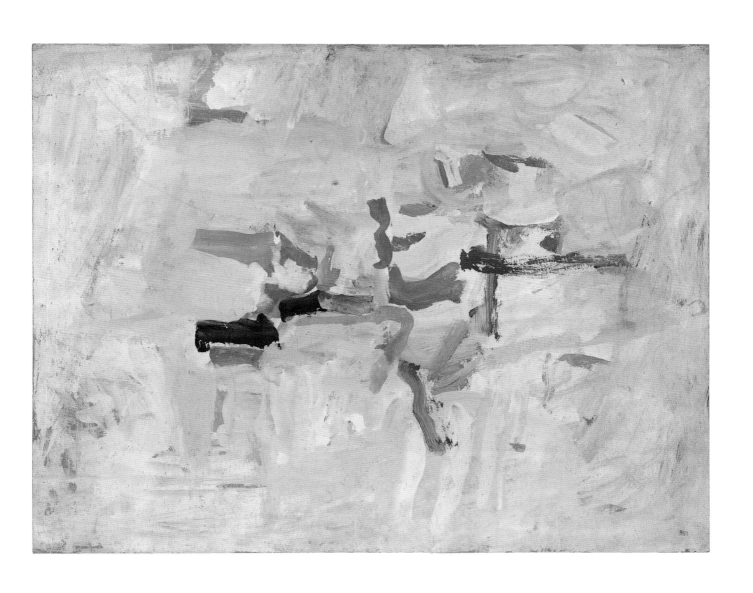

Untitled, c. 1950. Gouache on paper, 17½ x 22¾ in. (44.5 x 57.8 cm)

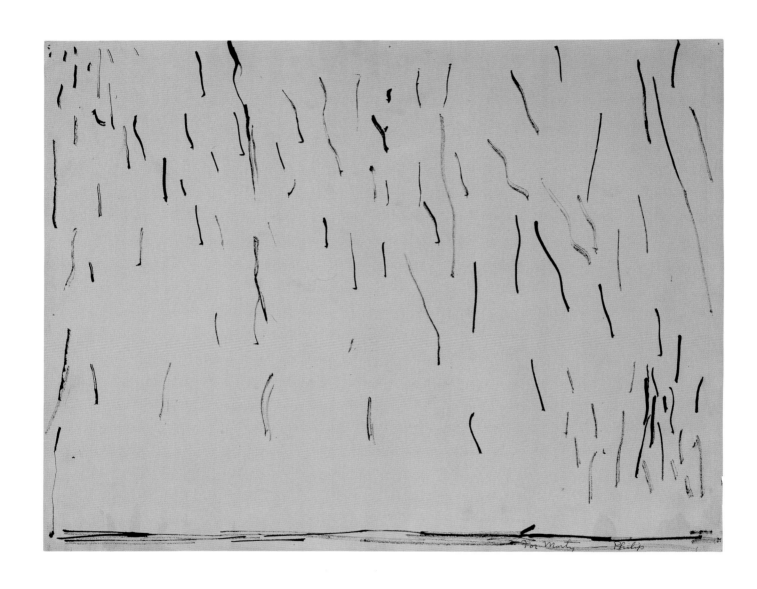

Untitled, 1952. Ink on paper, 17 x 21½ in. (43.2 x 54.6 cm). Inscribed: For Morty

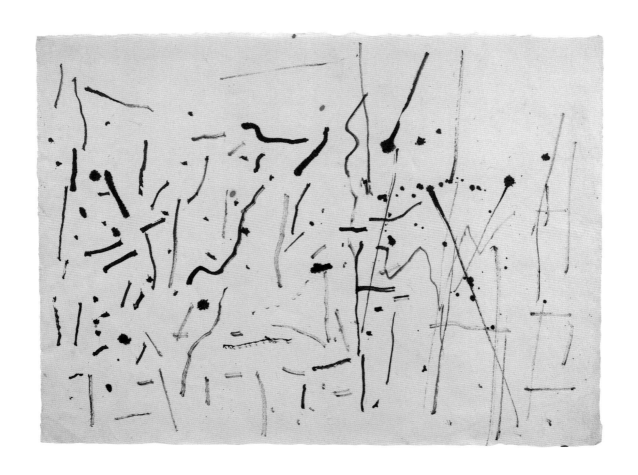

Untitled, c. 1950. Ink on paper, 12¼ x 16¼ in. (31.1 x 41.3 cm)

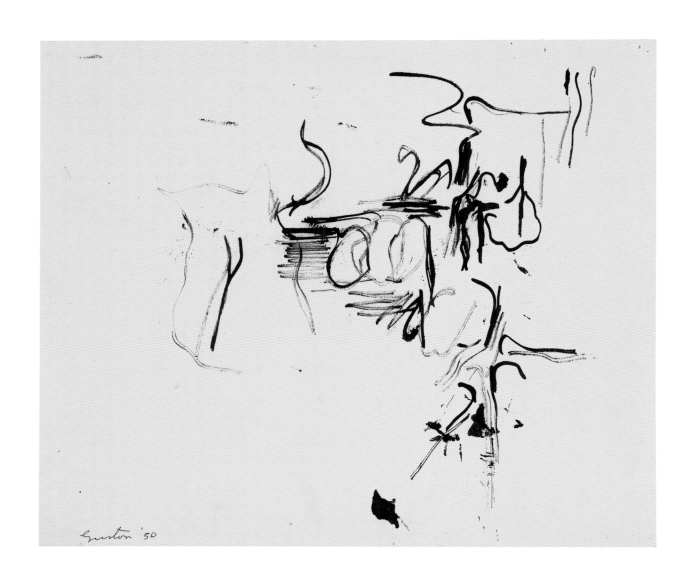

Untitled, 1950. Ink on paper, 17 x 20⅛ in. (43.2 x 51.1 cm)

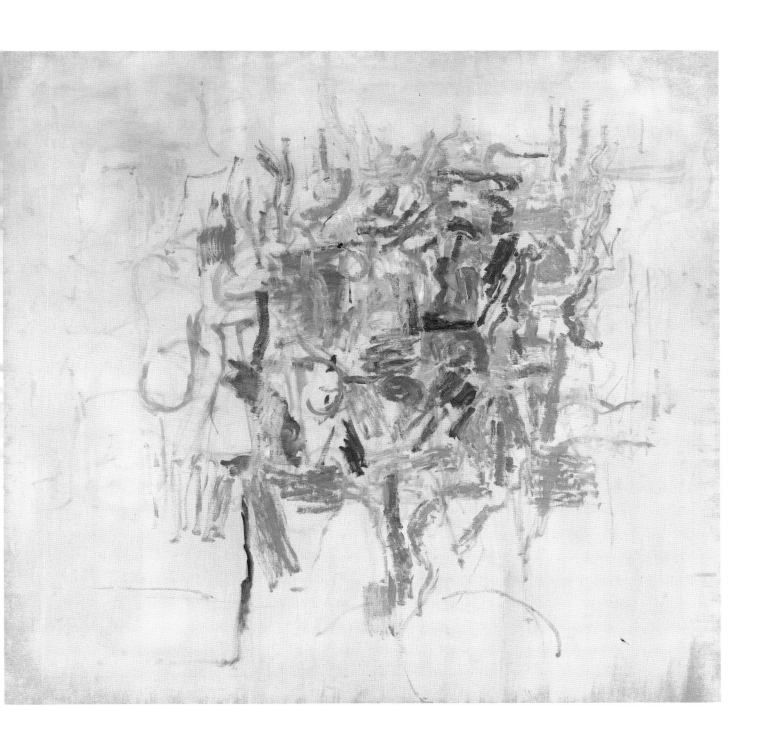

White Painting I, 1951. Oil on canvas, 57⅞ x 61⅞ in. (147 x 157.2 cm)

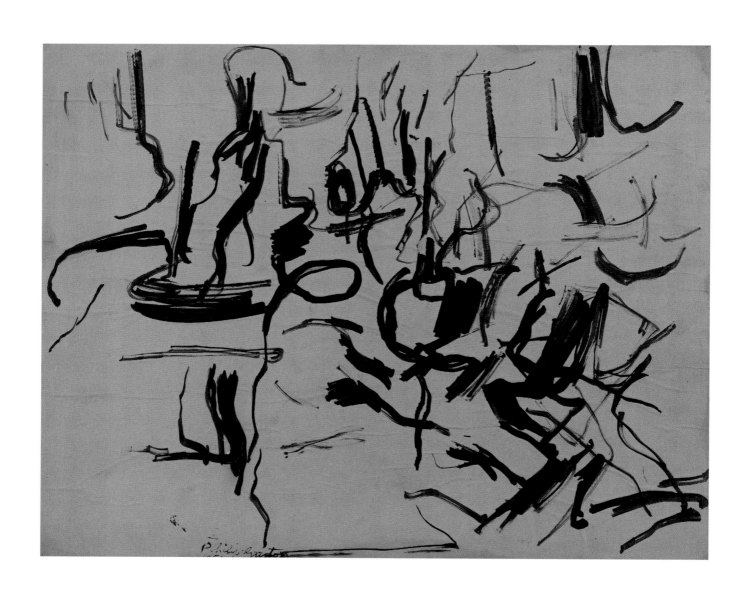

Untitled, 1951. Ink on paper, 18¾ x 23¾ in. (47.6 x 60.3 cm)

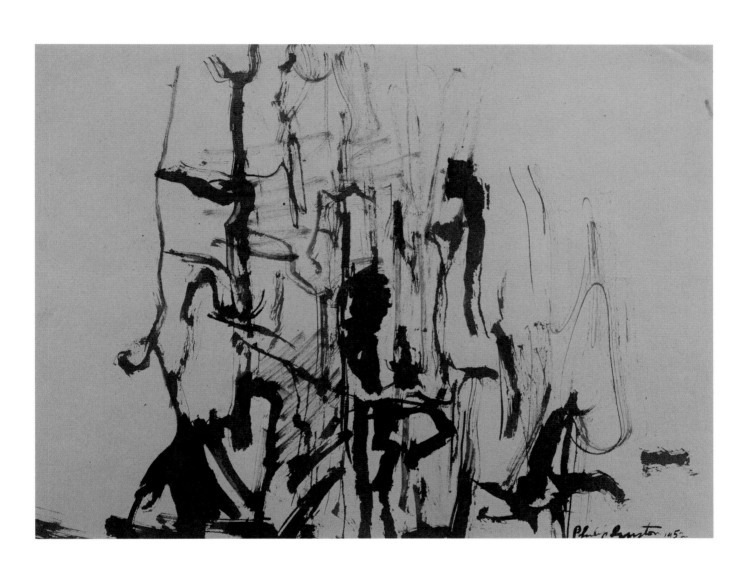

Untitled, 1952. Ink on paper, 16¼ x 21 in. (41.3 x 53.3 cm)

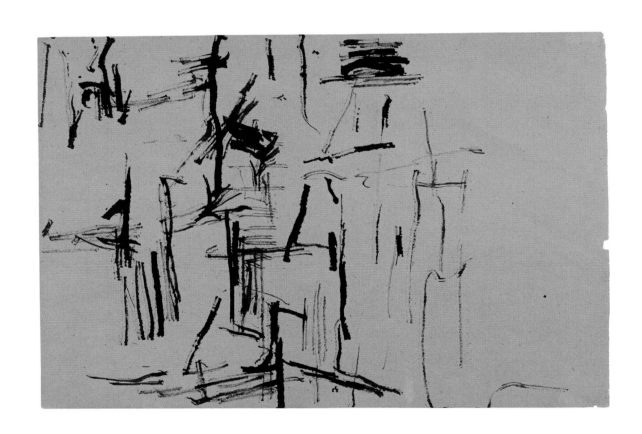

Untitled, c. 1952. Ink on paper, 12 x 17⅞ in. (30.5 x 45.4 cm)

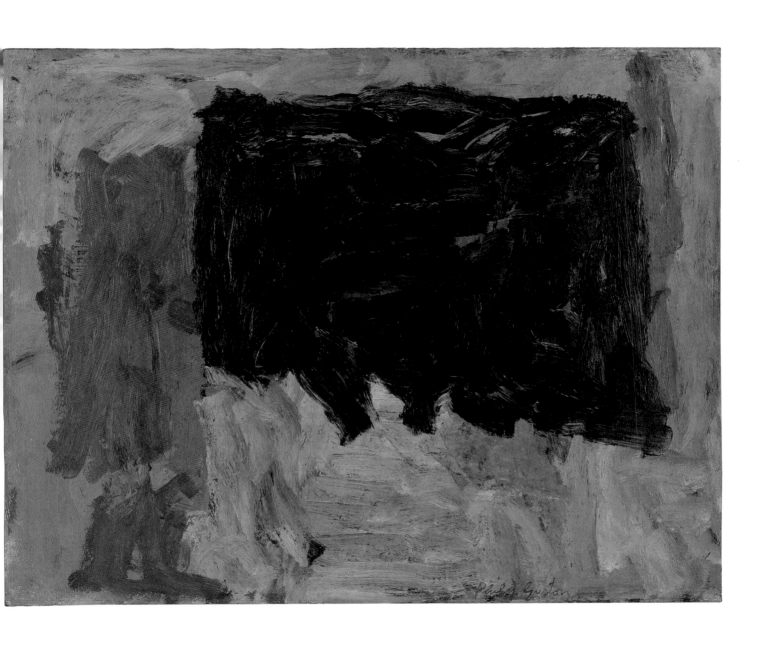

Close-Up II, 1959. Oil on panel, 23¼ x 29 in. (59 x 73.7 cm)

Franz Kline (1910–1962)

Herald, c. 1953–54. Oil on canvas and board, 57⅝ x 82¼ in. (146.4 x 208.9 cm)

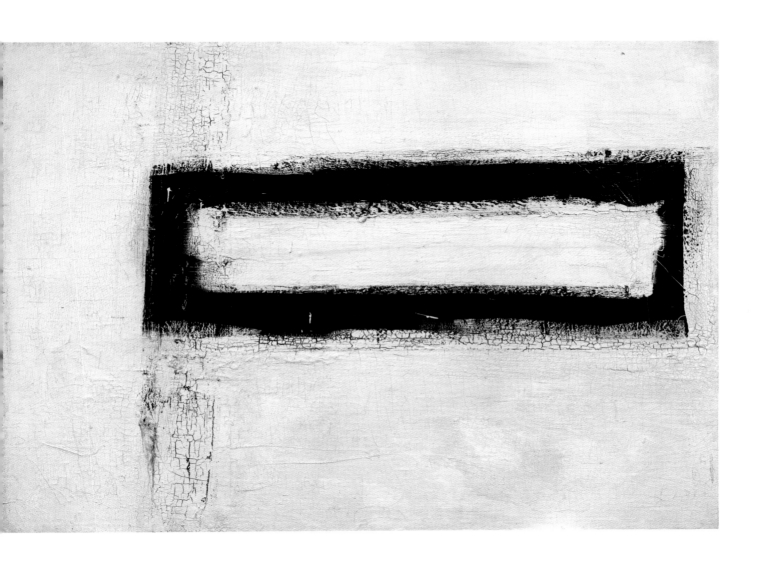

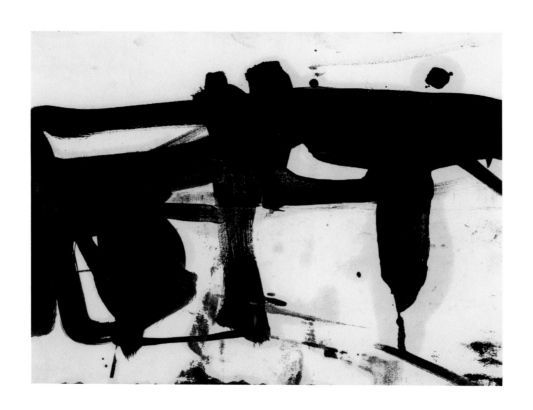

Untitled, 1953. Oil on paper, 8¼ x 10¾ in. (21 x 27.3 cm)

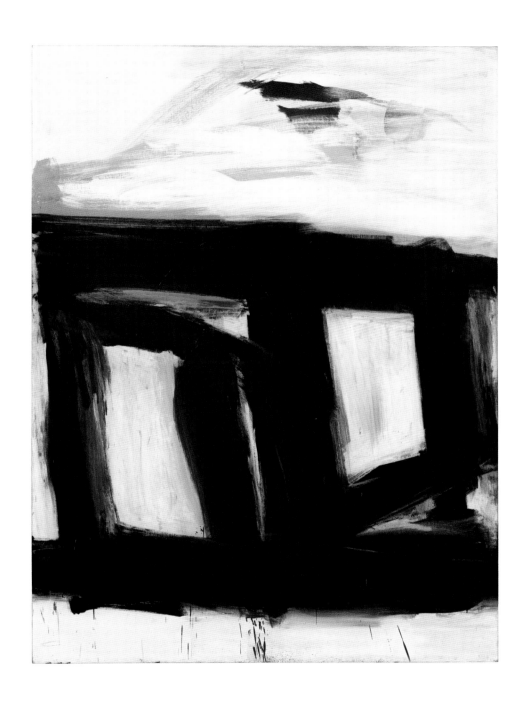

Zinc Door, 1961. Oil on canvas, 92½ x 67¾ in. (235 x 172.1 cm)

Joan Mitchell (1925–1992)

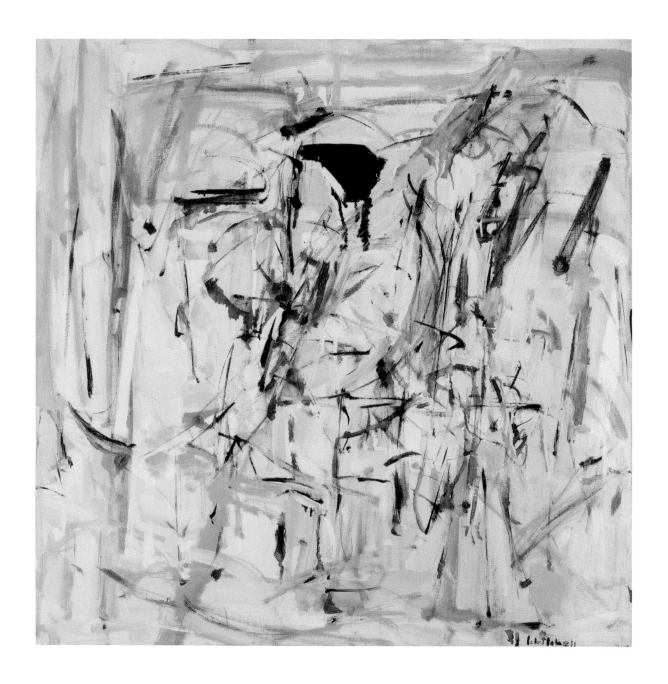

Untitled, 1954. Oil on canvas, 27 x 26 in. (68.6 x 66 cm)

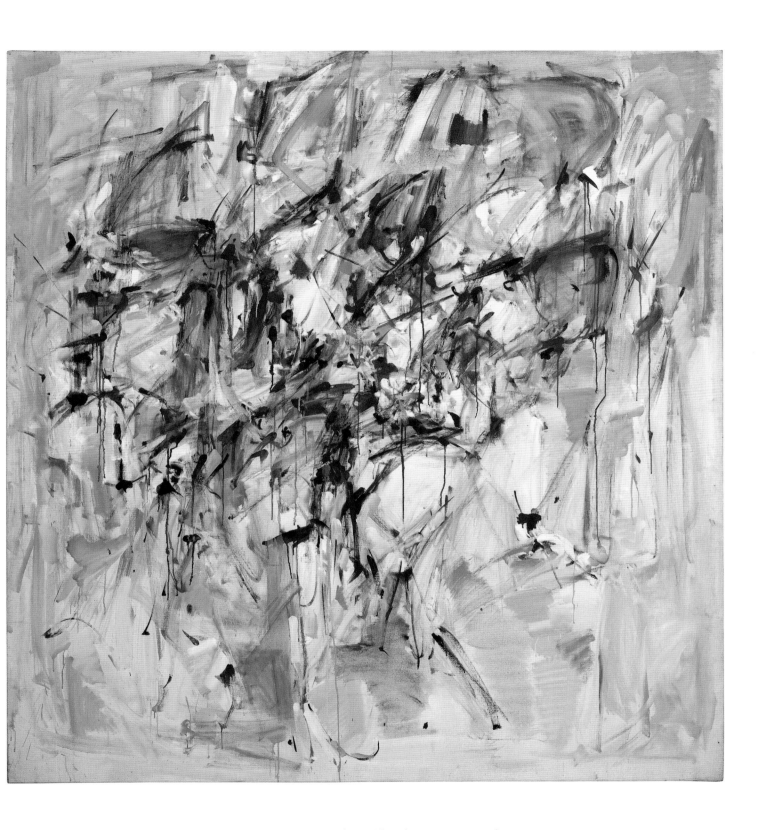

Rose Cottage, 1953. Oil on canvas, 71¾ x 68⅜ in. (182.2 x 173.7 cm)

Composition, c. 1959. Oil on canvas, 76¾ x 73¼ in. (195 x 186 cm)

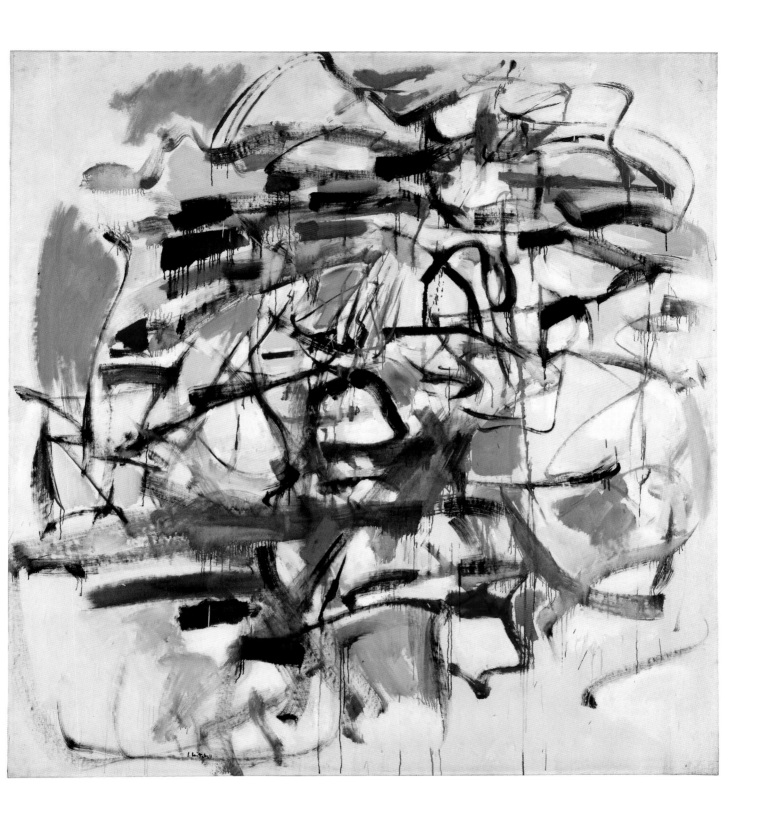

David Smith (1906–1965)

Forging IX, 1955. Varnished steel, 72½ x 7⅝ x 7⅝ in. (184.2 x 19.4 x 19.4 cm)

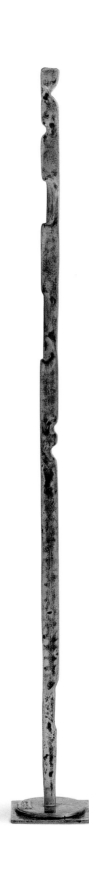

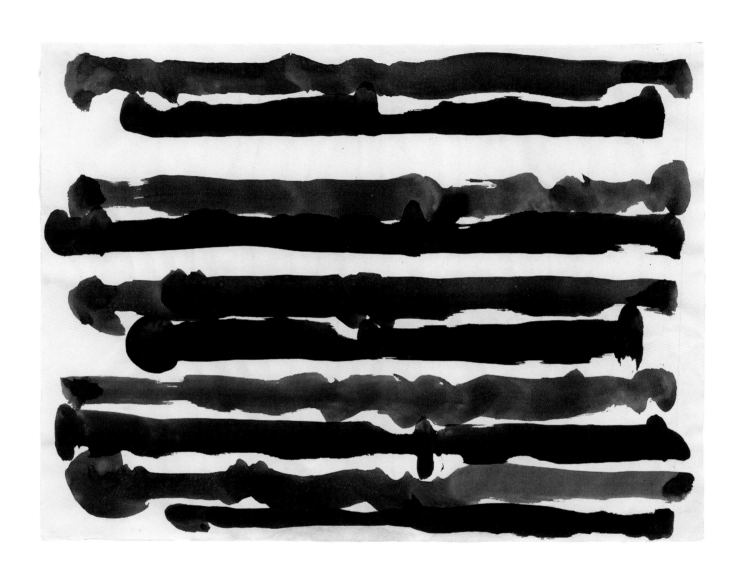

Untitled, 1955. Black ink and blue gouache on cream wove paper, 17⅝ x 22½ in. (44.8 x 57.2 cm)

Opposite: *Forging V*, 1955. Varnished steel, 74 x 8½ x 8½ (188 x 21.6 x 21.6 cm)

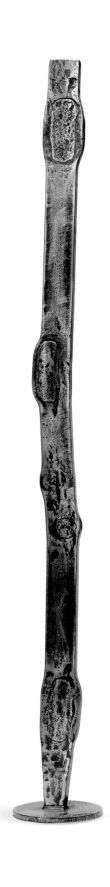

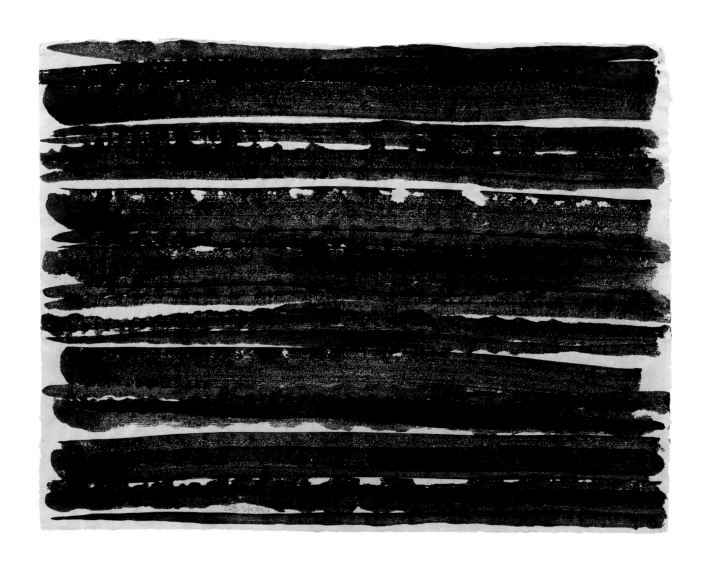

Untitled, 1955. Egg ink on paper, 17 x 21⅛ in. (43.2 x 53.7 cm)

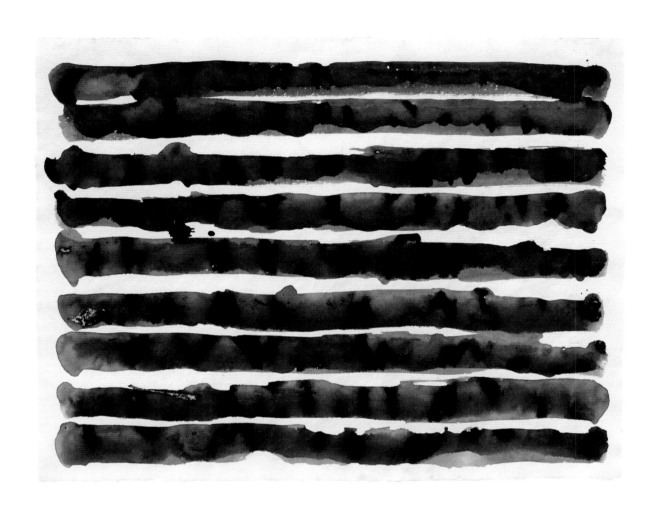

Untitled, 1955. Egg ink on paper, 15⅝ x 20¼ in. (39.7 x 51.4 cm)

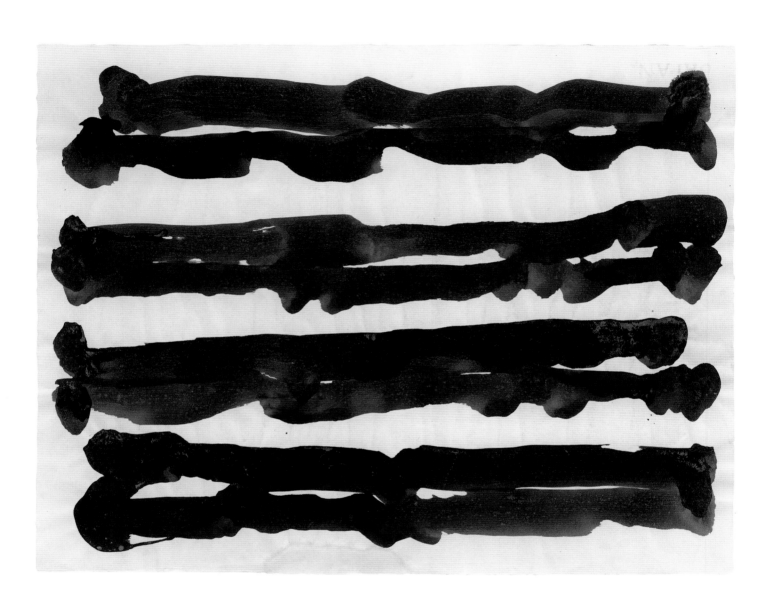

Untitled, 1955. Black egg ink (purple) on paper, 17½ x 22½ in. (44.5 x 57.2 cm)

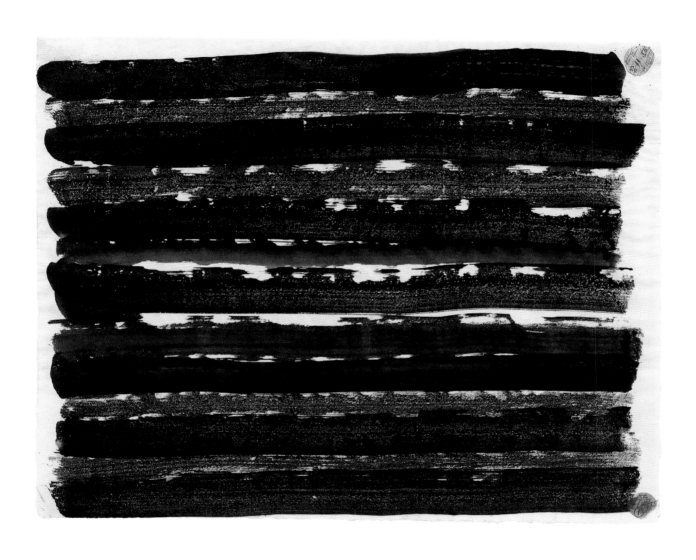

Untitled (2-10-55, 2-11-55 Grey Black), 1955. Egg ink on paper, 16⅞ x 21¼ in.
(42.9 x 54 cm)

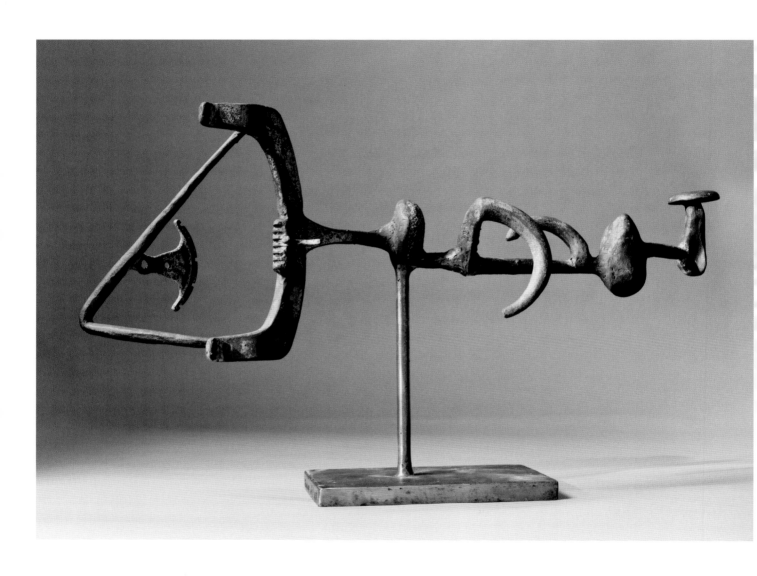

Horizontal, 9/4/52, 1952. Steel and brass, stainless-steel base, 17½ x 43¾ x 7 in.
(44.5 x 111.1 x 17.8 cm)

Checklist of the Exhibition

Louise Bourgeois

The Blind Leading the Blind, 1947–49
Wood, painted red and black, 69½ x 69 x 23 in.
(176.5 x 175.3 x 58.4 cm). Ed. 3/6
Collection The Easton Foundation
page 27

Figures Abstraites, 1947
Ink on tan paper, 10¾ x 8¼ in. (27.3 x 21 cm)
Collection The Easton Foundation
page 28

Untitled, 1949
Ink on paper, 10⅞ x 8½ in. (27.6 x 21.6 cm)
Collection The Easton Foundation
page 29

Untitled, 1949
Ink on paper, 8 x 51/4 in. (20.3 x 13.3 cm)
Collection The Easton Foundation
page 30

Breasted Woman, 1949–50, cast 1989
Bronze, paint, and stainless steel, 54 x 3½ x
3½ in. (137.2 x 8.9 x 8.9 cm). Ed. 5/6 + 1 AP
Courtesy Hauser & Wirth
page 31

Untitled, 1950
Ink on paper, 14 x 11 in. (35.6 x 27.9 cm)
Private Collection, New York
page 32

Untitled, 1950
Ink on paper, 11 x 8½ in. (27.9 x 21.6 cm)
Collection The Easton Foundation
page 33

Untitled, 1949
Ink on paper, 10½ x 7¼ in. (26.7 x 18.4 cm)
Verso: very fine drawing one of my favorites
[crossed out]
Collection The Easton Foundation
page 34

Untitled, 1950
Ink on paper, 11½ x 9¾ in. (29.2 x 24.8 cm)
Collection The Easton Foundation
page 35

Memling Dawn, 1951, cast 1992
Bronze, stainless steel, 62⅝ x 15 x 18 in.
(159 x 38.1 x 45.7 cm). Ed. 4/6 + 1 AP
Courtesy Hauser & Wirth
page 37

John Cage

"Lecture on Nothing," 1949
Corrected transcript, 8½ x 11 in.
(21.6 x 27.9 cm)
Courtesy Wesleyan University Press,
Wesleyan University, Connecticut
pages 38–41

Williams Mix for Magnetic Tape,
January 16, 1952
Holograph in black, green, orange pencil,
8⅝ x 11 in. (22 x 28 cm)
John Cage Music Manuscript Collection,
Music Division, The New York Public Library
for the Performing Arts, Astor, Lenox and
Tilden Foundations
pages 42–43

* Reading of "Lecture on Nothing," 1980s
Digitized sound file
Courtesy John Cage Trust, Bard College,
Annandale-on-Hudson, New York

* Excerpts from "Radio Happening I,"
July 9, 1966
Digitized sound file
Courtesy Mode Records, New York

* *Williams Mix*, 1952
Digitized sound file
Courtesy C. F. Peters Corporation

* *Music for Piano, No.1*, 1952
Holograph, signed in ink and pencil,
7⅛ x 10 ¼ in. (18 x 26 cm)
John Cage Music Manuscript Collection,
Music Division, The New York Public Library
for the Performing Arts, Astor, Lenox and
Tilden Foundations

* *Aria*, 1958
Manuscript, holograph in ink, 7⅛ x 10¼ in.
(18 x 26 cm)
John Cage Music Manuscript Collection,
Music Division, The New York Public Library
for the Performing Arts, Astor, Lenox and
Tilden Foundations

** Not in catalogue*
*** Not in exhibition*

** Music of Changes*, 1952
Digitized sound file
Courtesy Mode Records

4'33", 1952
Score, 8⅜ x 6⅜ in. (21.4 x 16.4 cm)
John Cage Music Manuscript Collection,
Music Division, The New York Public Library
for the Performing Arts, Astor, Lenox and
Tilden Foundations
page 45

Aria, 1958
Finished score, 7⅛ x 10¼ in. (18 x 26 cm),
and digitized sound file
Courtesy C. F. Peters Corporation and Wergo/
Schott Music & Media
pages 46–53

Morton Feldman

Extensions for Orchestra, 1951
Score, 7 x 8⅝ x ¼ in. (17.8 x 21.9 x 0.6 cm)
Manuscript inscribed: Dedicated to Philip,
Feb 13, 1958; To Philip/For himself, his
paintings and his friendship
Courtesy The Estate of Philip Guston
and Hauser & Wirth
pages 54–57

For String Quartet, April 10, 1956
Finished score, 14½ x 32½ in. (36.8 x 82.6 cm)
Inscribed: This composition is/dedicated to
Philip/Guston whose/love and respect/without
which-/this work would/not be possible
Courtesy The Estate of Philip Guston
pages 58–59

Projection I, 1950
Finished score, 8⅜ x 11⅛ in. (21.3 x 28.3 cm),
and digitized sound file
Courtesy C. F. Peters Corporation and
Mode Records
pages 60–63

Intersection 4, November 22, 1953
Finished score, 8⅜ x 11⅛ in. (21.3 x 28.3 cm)
Courtesy C. F. Peters Corporation
pages 64–67

** Soundtrack for Jackson Pollock*, 1950–51
Digitized sound file
Courtesy Mode Records

** Extension 4 (For Three Pianos)*, 1953
Digitized sound file
Courtesy Mode Records

** For Franz Kline*, 1962
Digitized sound file
Courtesy Wergo/Schott Music & Media

Philip Guston

Voyage, 1956
Oil on canvas, 72 x 76 in. (182.9 x 193 cm)
Collection Albright-Knox Art Gallery, Buffalo,
New York; Mildred Bork Conners & Joseph E.
Conners Fund, 2004, 2004:17
page 69

Untitled, 1952
Ink on paper, 18 x 19⅞ in. (45.7 x 50.4 cm)
Courtesy Estate of Philip Guston and
Hauser & Wirth
page 70

Untitled, c. 1950
Gouache on paper, 17½ x 22¾ in.
(44.5 x 57.8 cm)
Courtesy Estate of Philip Guston and
Hauser & Wirth
page 71

Untitled, 1952
Ink on paper, 17 x 21½ in. (43.2 x 54.6 cm)
Inscribed: For Morty
Collection Albright-Knox Art Gallery, Buffalo,
New York; Gift of Seymour H. Knox, Jr., 1957
page 72

Untitled, c. 1950
Ink on paper, 12¼ x 16¼ in. (31.1 x 41.3 cm)
Courtesy Estate of Philip Guston and
Hauser & Wirth
page 73

Untitled, 1950
Ink on paper, 17 x 20⅛ in. (43.2 x 51.1 cm)
Courtesy Estate of Philip Guston and
Hauser & Wirth
page 74

White Painting I, 1951
Oil on canvas, 57⅞ x 61⅞ in. (147 x 157.2 cm)
Courtesy The Estate of Philip Guston and
San Francisco Museum of Modern Art,
T. B. Walker Foundation Fund Purchase
page 75

Untitled, 1951
Ink on paper, 18¾ x 23¾ in. (47.6 x 60.3 cm)
Courtesy Estate of Philip Guston and
Hauser & Wirth
page 76

Untitled, 1952
Ink on paper, 16¼ x 21 in. (41.3 x 53.3 cm)
Courtesy Estate of Philip Guston and
Hauser & Wirth
page 77

Untitled, c. 1952
Ink on paper, 12 x 17⅞ in. (30.5 x 45.4 cm)
Courtesy Estate of Philip Guston and
Hauser & Wirth
page 78

Close-Up II, 1959
Oil on panel, 23¼ x 29 in. (59 x 73.7 cm)
Collection Howard Karshan, New York
page 79

Franz Kline

Herald, c. 1953–54
Oil on canvas and board, 57⅝ x 82¼ in.
(146.4 x 208.9 cm)
Private Collection, New York
page 81

Untitled, 1953
Oil on paper, 8¼ x 10¾ in. (21 x 27.3 cm)
Private Collection, Colorado
page 82

** *Zinc Door*, 1961
Oil on canvas, 92½ x 67¾ in. (235 x 172.1 cm)
Private Collection
page 83

Joan Mitchell

Untitled, 1954
Oil on canvas, 27 x 26 in. (68.6 x 66 cm)
Private Collection, Colorado
page 84

Rose Cottage, 1953
Oil on canvas, 71¾ x 68⅜ in. (182.2 x 173.7 cm)
Private Collection, New York
page 85

Composition, c. 1959
Oil on canvas, 76¾ x 73¼ in. (195 x 186 cm)
Private Collection, Switzerland
page 87

David Smith

Forging IX, 1955
Varnished steel, 72½ x 7⅝ x 7⅝ in.
(184.2 x 19.4 x 19.4 cm)
Courtesy The Estate of David Smith and
Hauser & Wirth
page 89

Untitled, 1955
Black ink and blue gouache on cream wove
paper, 17⅝ x 22½ in. (44.8 x 57.2 cm)
Courtesy The Estate of David Smith and
Hauser & Wirth
page 90

** *Forging V*, 1955
Varnished steel, 74 x 8½ x 8½ in.
(188 x 21.6 x 21.6 cm)
Private Collection; Courtesy The Estate of
David Smith
page 91

Untitled, 1955
Egg ink on paper, 17 x 21⅛ in.
(43.2 x 53.7 cm)
Courtesy The Estate of David Smith and
Hauser & Wirth
page 92

Untitled, 1955
Egg ink on paper, 15⅝ x 20¼ in.
(39.7 x 51.4 cm)
Courtesy The Estate of David Smith and
Hauser & Wirth
page 93

Untitled, 1955
Black egg ink (purple) on paper, 17½ x 22½ in.
(44.5 x 57.2 cm)
Courtesy The Estate of David Smith and
Hauser & Wirth
page 94

Untitled (2-10-55, 2-11-55 Grey Black), 1955
Egg ink on paper, 16⅞ x 21¼ in. (42.9 x 54 cm)
Courtesy The Estate of David Smith and
Hauser & Wirth
page 95

Horizontal, 9/4/52, 1952
Steel and brass, stainless-steel base,
17½ x 43¾ x 7 in. (44.5 x 111.1 x 17.8 cm)
Courtesy The Estate of David Smith and
Hauser & Wirth
page 96

Acknowledgments

Nothing and Everything: Seven Artists, 1947–1962 came to fruition through the timely efforts of many colleagues, friends, and individuals, without any of whom the project would have been diminished.

At the Louise Bourgeois Studio: Jerry Gorovoy and Wendy Williams. At the John Cage Trust: Laura Kuhn, Director, and John Cage Professor of Performance Art, Bard College, and Emy Martin. At the Philip Guston Foundation: Musa Mayer, President, and Sally Radic, Website and Catalogue Raisonné Manager. At the Joan Mitchell Foundation: Christa Blatchford, Executive Director; Laura Morris, Archivist; and Kim Osti, Collections Manager. At the David Smith Estate: Peter Stevens, Executive Director, and Susan Cooke, Associate Director.

Additionally, John Bewley, Associate Librarian and Archivist, Music Library, State University of New York at Buffalo; Brian Brandt, President, Mode Records; Michael Brenson, Sculpture Faculty, Milton Avery Graduate School of the Arts, Bard College; Gene Caprioglio, Vice President for New Music and Rights, C. F. Peters Corporation; Lisa Rafalson, Maia and Mina Dreishpoon; David Felder, Birge-Cary Chair in Music Composition, SUNY Buffalo; Jonathan Golove, Department Chair and Associate Professor, Department of Music, SUNY Buffalo; Pamela Hatley, Head of Publications, Albright-Knox Art Gallery; Jonathan Hiam, Curator, American Music Collection and Rodgers and Hammerstein Archives of Recorded Sound, New York Public Library for the Performing Arts; Norman Kleeblatt, Susan and Elihu Rose Chief Curator, Jewish Museum; Suzy Tabara, Director of Special Collections and Archives, Olin Library, Wesleyan University; and Christian Wolff, Composer.

I also extend my sincere thanks to the able staff at Hauser & Wirth, whose undaunted esprit de corps graced every aspect of this collaboration.

D.D.
January 5, 2017

Published on the occasion of the exhibition
*Nothing and Everything: Seven Artists,
1947–1962*, presented at Hauser & Wirth,
32 East 69th Street, New York, N.Y.
February 2–April 1, 2017

Exhibition organized by Douglas Dreishpoon

Editor: Douglas Dreishpoon
Editorial coordination: Diana Murphy
Project assistance:
 Sara Rosenblum and Jake Brodsky
Design and typesetting:
 Miko McGinty and Paula Welling
Color separations: LUP AG, Cologne
Production coordination: Peter Roeckerath
Printed and bound by Snoeck
 Verlagsgesellschaft mbH, Cologne

*Nothing and Everything: Seven Artists,
1947–1962* © 2017 Hauser & Wirth
Publishers, www.hauserwirth.com

Essay © 2017 Douglas Dreishpoon

Page 16: top left, © Pollock-Krasner
Foundation / 2017, ProLitteris, Zurich; top
right, © The Willem de Kooning Foundation /
2017, ProLitteris; bottom left, © 1998 Kate
Rothko Prizel & Christopher Rothko / 2017,
ProLitteris, Zurich; bottom right, © 2017,
ProLitteris, Zurich. Photograph courtesy
Douglas Dreishpoon
Page 19, photograph © Robert Freson
Page 23 right, © Succession Alberto
Giacometti / 2017, ProLitteris, Zurich
Pages 79–81, © 2017, ProLitteris, Zurich
Pages 84, 85, 87, © Estate of Joan Mitchell

Library of Congress
Cataloging-in-Publication Data
Names: Dreishpoon, Douglas, author. | Hauser
 & Wirth New York, organizer, host institution.
Title: Nothing and everything : seven artists,
 1947–1962 : Bourgeois, Cage, Feldman,
 Guston, Kline, Mitchell, Smith / Douglas
 Dreishpoon.
Description: New York : Hauser & Wirth
 Publishers, 2017. | "Published on the
 occasion of the exhibition Nothing and
 Everything: Seven Artists, 1947–1962
 Hauser & Wirth, 32 East 69th Street,
 New York February 2–April 1, 2017." |
 Includes bibliographical references.
Identifiers: LCCN 2016058720 | ISBN
 9783952446171 (pbk.)
Subjects: LCSH: Arts, American—New York
 (State)—New York—20th century—
 Exhibitions. | Art and music—New York
 (State)—New York—History—20th
 century—Exhibitions.
Classification: LCC NX511.N4 D74 2017 |
 DDC 700.92/273—dc23
LC record available at
 https://lccn.loc.gov/2016058720

Available in North America through
ARTBOOK | D.A.P.
155 Sixth Avenue, 2nd floor
New York, N.Y. 10013
Tel 212 627 1999 | Fax 212 627 9484

ISBN 978-3-9524461-7-1

Printed in Germany